OTLEY

THROUGH TIME

Otley Museum and Archive Trust

Compiled and with notes by
Stuart Pickersgill; photographs
by Andrew Beason.

AMBERLEY PUBLISHING

 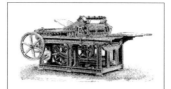

Otley Museum and Archive Trust: Registered Company No. 8021978
Registered Charity No. 1148873; Accredited Museum No. 1234

Otley Museum and Archive Trust. A comprehensive collection of documents and photographs tells the story of this Wharfedale community from prehistoric times to the twentieth century. A fascinating insight into Otley's heritage and a key resource for both the amateur and professional researcher. Our Documentary and Photographic Archive and expertise in local and family history is well used by both personal and professional researchers worldwide. Our accreditation by both regional and national bodies recognises the standards we maintain in our work.

Wellcroft House
Otley Cycle Club
Crow Lane
Otley
West Yorkshire
LS21 1TZ
Tel.: 01943 468181

www.otleymuseum.org
otleymuseum@btconnect.com

First published 2013

Amberley Publishing
The Hill, Stroud, Gloucestershire, GL5 4EP
www.amberley-books.com

Copyright © Otley Museum and Archive Trust, 2013

The right of Otley Museum and Archive Trust to be identified as the Author of this work has been asserted in accordance with the Copyrights, Designs and Patents Act 1988.

ISBN 978 1 4456 1895 1 (print)
ISBN 978 1 4456 1907 1 (ebook)

British Library Cataloguing in Publication Data.
A catalogue record for this book is available from the British Library.

Typesetting by Amberley Publishing.
Printed in Great Britain.

Introduction

Otley, West Yorkshire, in the valley of the River Wharfe, is an ancient town with an interesting history. Said to be named after Otta, a Saxon leader from around the eigth century, it is called Otelai in the Domesday Book of 1086. There is a thirteenth-century church, where a plaque on the wall lists the first vicar in 1267, but there are remains of Saxon crosses from the churchyard which have been dated to the eigth century. So why did Otley develop as it did? Opinion is that the river was fordable at this point and a bridge (now a Scheduled Ancient Monument) was first mentioned in 1228, around the same time Otley was granted a Royal Charter to hold a market. The town was under the Lordship of the Archbishops of York from the first half of the thirteenth century; their palace was situated by the river, where there are still remains excavated in the mid-1960s. The Archbishops laid out burgage plots on Boroughgate, Walkergate and Kirkgate to attract merchants and tradespeople. Bondgate was for tenants who did not have 'burgage' privileges.

As the town gradually grew with its street and cattle markets, there was a pattern of stone built, vernacular architecture in the inns, stables, barns, corn stores and tanneries, which can still be seen today. In the early nineteenth century, the source of power from the river was harnessed for worsted spinning and paper mills. In 1865, with the coming of the railway link, the new industry of printing machine engineering was developed. Otley became famous worldwide with the Wharfedale printing machine. Most of the old trades with interesting names such as skinner, tanner, currier, fellmonger, cordwainer, cartwright, ropemaker and candlemaker, are now gone. There are still a number of shops which have been trading in the town for many years: Barber's, the tobacconist, has been trading in Otley since 1867 and Sinclair's, who manufacture stationary products, have been in Otley since 1854. Since the 1930s housing has expanded, especially to the north of the river, with houses built by the local council and, in the 1970s, large private housing estates were built on the rising hills to the north and west of the town. This has changed the character of the town since the demise of the old industries, as fewer people now work in Otley; most commute to the large cities of Leeds and Bradford, or even further afield.

Through the selection of photographs presented in the title, we aim to show how the look of the town has changed from around the late 1800s, when the camera became popular, allowing us a glimpse of the streets of the past. We have tried to take the new photographs from as close

as possible to the original view but, as many were taken from the middle of what are now busy roads, it proved difficult and sometimes dangerous; the climb up the Otley parish church tower was particularly exhilarating to say the least! The museum has collected and been given over 1,000 old photographs over the last fifty years, many in the form of postcards. We are very grateful for the donors' generosity, which has led to the the opportunity to share them with as many people as possible. A number of the postcards were produced in Otley from publishers such as Mounsey, Walker, Robinson, Stephenson, Brown and Pickles, and most date between 1900 and 1918 – the golden age of postcard production. Many photos speak for themselves, whilst others need background explanation, but all are just a page in the continuing story of the town which is constantly changing. New technology has altered shopping habits (now goods can be bought at the click of a button and delivered to your door from anywhere in the world) but the markets live on. There are still weekly cattle markets, town markets on Fridays and Saturdays, and a smaller one on Tuesdays, plus a monthly farmers' market, so a tradition which started in the thirteenth century is ongoing and expanding. Who knows what Otley will look like in another 100 years, but here we have a snapshot in time with which to compare.

It has been a pleasure to put this selection together and Andrew, the photographer, has forgiven me for insisting we shoot the new photographs from the same place, however dangerous! Otley Museum will continue to collect as much as we can to serve as a central point at which historical resources can be conserved, recorded and interpreted. At present we are looking for a new permanent home where we can display our archive and artefacts. We are a nationally accredited museum, a charity, and now a registered company, which carries out its work on an entirely voluntary basis, relying on grants, donations and our friends scheme for our funding. Hopefully this book may inspire people to support us. I hope you enjoy browsing through the book as much as I have enjoyed putting it together.

Stuart Pickersgill

Acknowledgements

I would like to thank all the Otley Museum Volunteers who helped with this book: their enthusiasm and hard work keeps the museum running.

Also thanks to Paul Wood for checking the historical details, Meg Morton for the visit to the parish church tower, and all the generous people who have donated photographs, documents and objects to the museum over the years, in order to keep the history of our town alive.

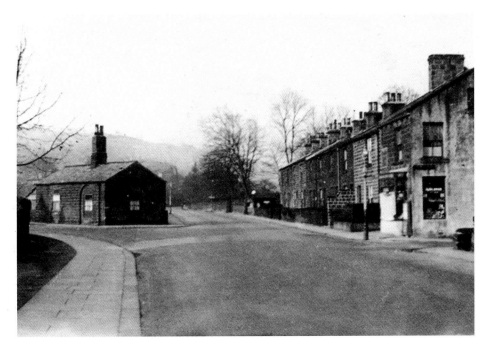

The Bar House, Junction of Bradford Road and West Chevin Road
This is where the tolls were once paid for use of the turnpike roads in and out of Otley; the money collected was used for the upkeep of the roads. There were originally four toll-bars, including this one; the others were situated on Ilkley Road, Pool Road and the bottom of East Chevin Road (the old Leeds Road). Tolls were abolished in 1889 and the building in this photograph was used as a private house until its demolition in 1936.

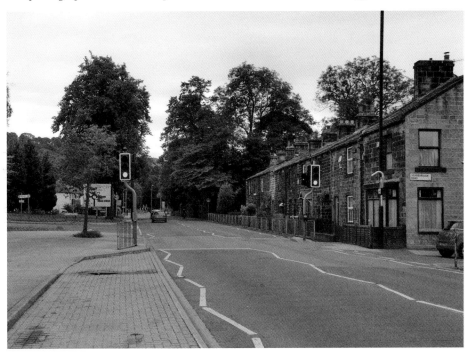

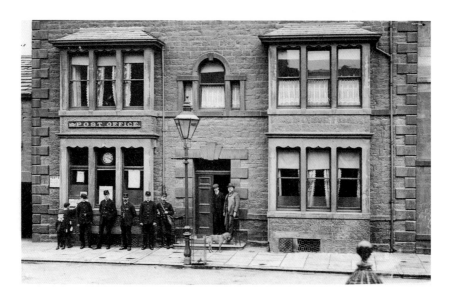

Post Office, No. 54 Boroughgate

The post office at No. 54 Boroughgate was opened in 1896, having moved from Manor Square. Two clerks and eight postmen made three deliveries a day to Otley and the local villages. Alterations to the eighteenth-century building included new bay windows, a sorting room and mail cart sheds. A new purpose-built post office was later built on Nelson Street, which opened on 19 February 1941. The builder, Tom Smith, presented the chairman of the council, Stanley Wilkinson, with a key, and he purchased the first stamp to be issued, which he affixed to a letter and posted to his wife to keep as a memento of the opening.

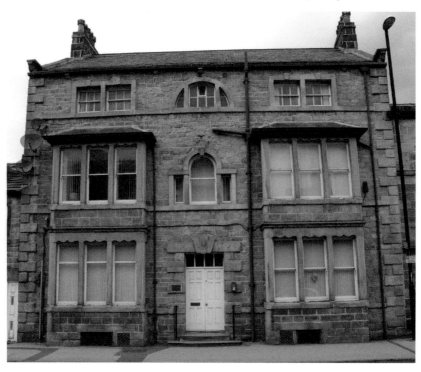

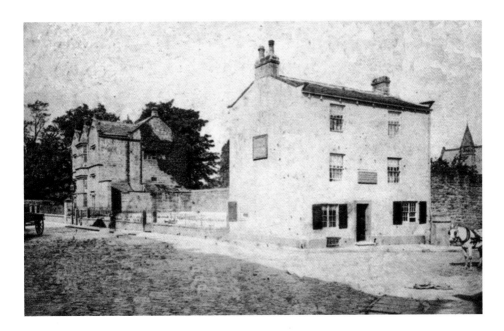

The Royal Oak, Clapgate, *c.* **1880.**

In the background of the Royal Oak public house at the top of Bridge Street, the old grammar school can be seen. The 300-year-old building was extended and the entrance moved to Clapgate as it became a two-storey building with larger windows. The space between the inn and grammar school is said to have been used as sheep pens until 1880. The building closed in 1970 and became a solicitor's office, but the old pub sign still remains, carved in stone, above the Clapgate entrance, while the dated sign can be seen above the original entrance on Bridge Street.

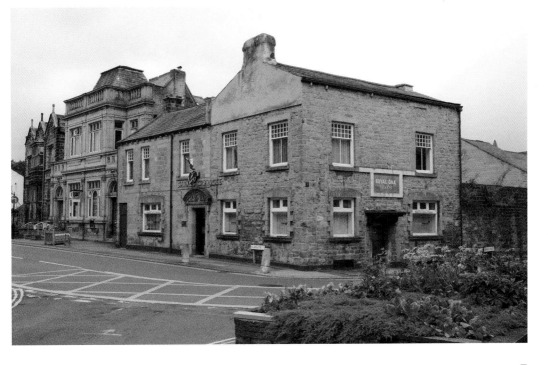

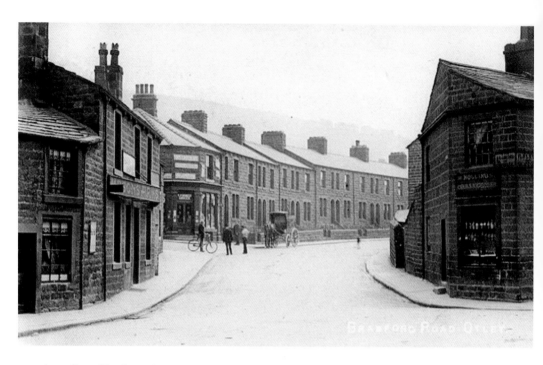

Junction of Bradford Road and Ilkley Road, Top of Westgate

This short stretch of road has the local name of Piper Lane. The pub on the left is the Mason's Arms, which started off as one or more cottages in the late eighteenth century. It became a beerhouse in the mid-nineteenth century and was only named the Mason's Arms in 1855. The buildings on the right (a shop and houses) were demolished in 1961. The Mason's is now a private house, as is the other shop next to the figures in the background.

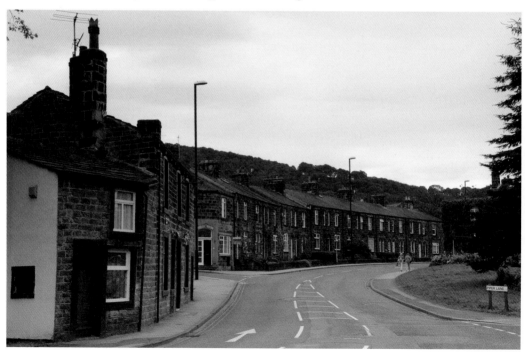

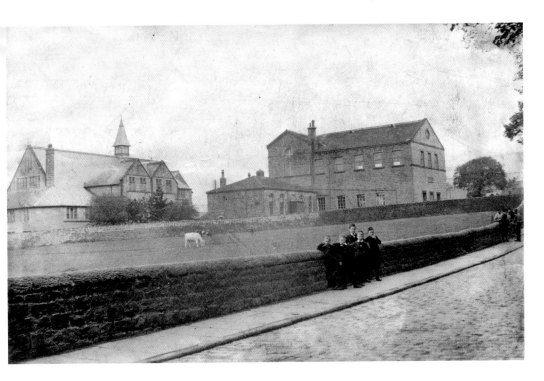

Bridge Street, 1896

On the right, the imposing but rather grim-looking building is the old Salem chapel, opened in 1826 for the Independents, a group of Christian Nonconformists who broke away from the established Church. It was demolished at the end of the nineteenth century, and the present church building opened in 1899. The Sunday school on the left dates back to 1882. Part of the original wall, where the boys are standing, is visible in the modern photograph.

9

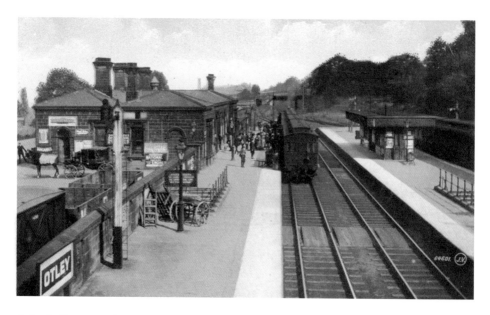

Otley Railway Station

The railway station opened in 1865 and closed in 1965. The waiting room on the island platform was reached by the tiled subway; the steps are on the left behind the carts. In its 100-year existence, it handled passengers and goods as well as wartime troop trains. Livestock was also transported and could be kept in the 'cattle docks' close by in East Chevin Road. It was particularly busy during the Otley Agricultural Show, when livestock were walked down Station Road and through the town to the showground. The travelling circus even had elephants sent to the station to be walked through the town. The bypass, which follows the route of the old railway line, was built in the mid-1980s to relieve traffic congestion in the town.

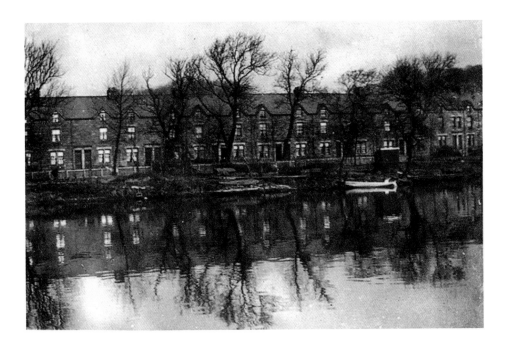

Bridge Avenue

The front of Bridge Avenue, prior to the laying out of the park in 1924. This photograph, taken in the 1930s, shows a small boathouse and boat. The local newspaper reported in 1924 that some of the land was used as 'pleasure gardens' by the residents of Bridge Avenue, and plots were purchased by the council to make the open space for the section of the park near the bridge.

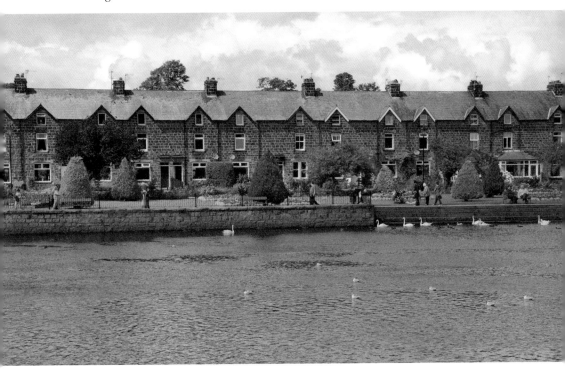

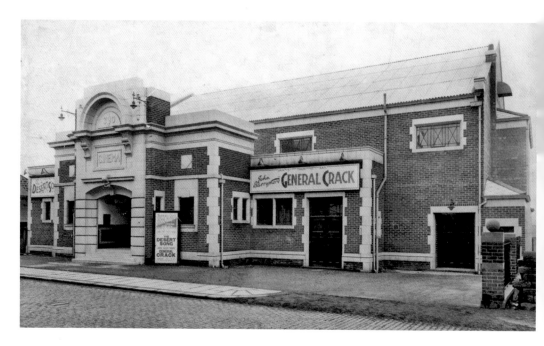

Cinema, Beech Hill

The cinema on Beech Hill, built by George Renwick of Otley, was opened in October 1930. The architect Oswald Holmes used glazed bricks from Shaw's of Darwen, Lancashire, which made the building stand out as most of Otley is built in stone. The first film shown was *The Flame of Love*, starring Anna May Wong. Before television, the cinema was a popular and cheap form of evening entertainment, and in its early years during the war, the programme of films was changed regularly, showing several different films every week. As the cinema gradually attracted fewer customers, it became a bingo hall in the late 1960s and was demolished in 2000.

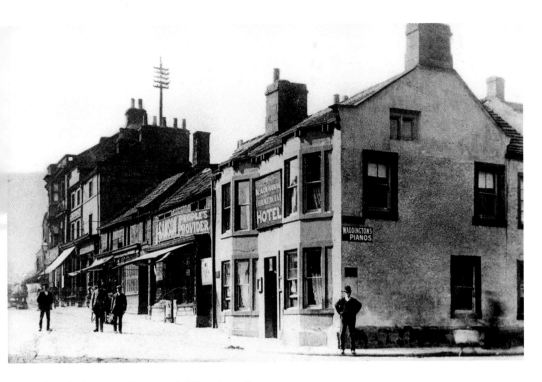

The Black Horse Commercial Hotel, *c.* 1894

Situated on Kirkgate opposite the Market Place, the Black Horse was a coaching inn with stables to the rear. Carriers used it as a departure point to local villages and towns, and even as far away as York. It was completely rebuilt in 1901 by Mastons of Otley as a classical Victorian building, with accommodation, a function room and extensive stabling.

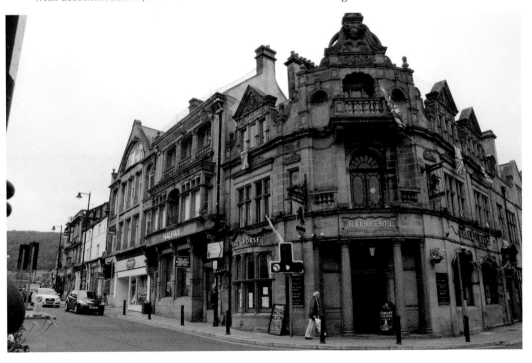

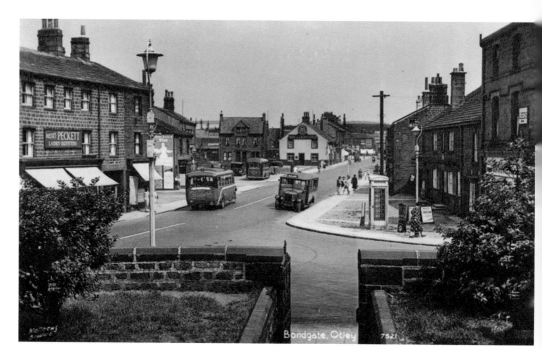

Bondgate, 1930s

Bondgate in the 1930s, with Samuel Ledgard buses waiting for passengers before the bus station opened in 1939. The front of the Bowling Green pub is being used to park cars and buses, and the space behind them is where Grove House stood until 1935. The photograph was taken from the parish church, Otley's oldest building.

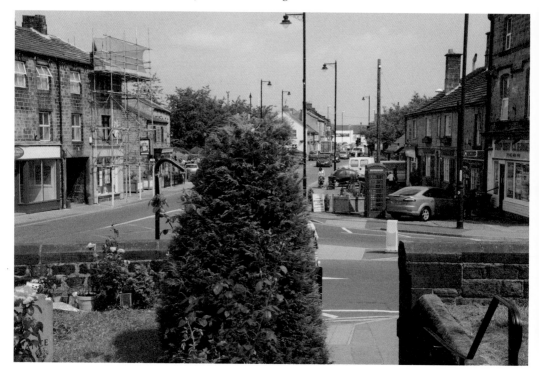

Burras Lane, 1930

This photograph of Burras Lane, dated Wednesday 25 April 1930, shows the Otley 2nd Scout Troop, one of the oldest in Wharfedale, started by Revd J. Granville Biggs, who was curate at Otley parish church at the time. The troop, led by a bugle band, paraded to the church for a service, followed by campfire singing at Burras Lane School. The road was much narrower than it is now, as all the buildings on the left were demolished to widen the road and make a car park.

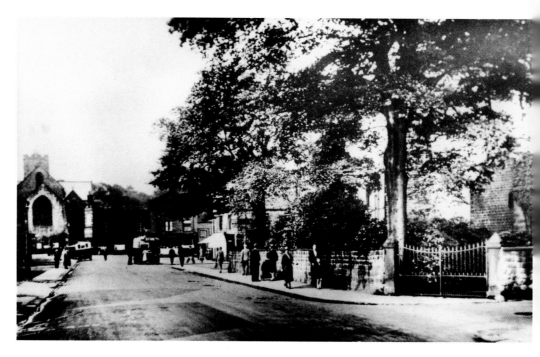

Bondgate, 1932

A postcard from 1932 shows a view from Bondgate looking towards the parish church, with Ledgard's buses waiting for passengers. The gates and trees stand at the entrance to Grove House, dating back to around 1775. This was the residence of the Revd Roger Wilson, Curate of Pool (1776–89), and headmaster of the grammar school (1781–89). A wealthy sporting parson, he kept his hunting hounds across the road. Later occupants included the Walkers, who had a shop on Kirkgate, and H&M Suttle furniture dealers. The council then purchased it and it was demolished in 1935.

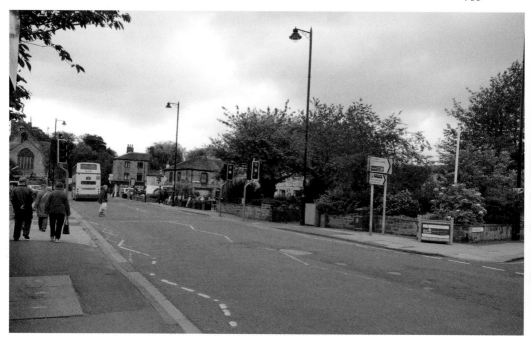

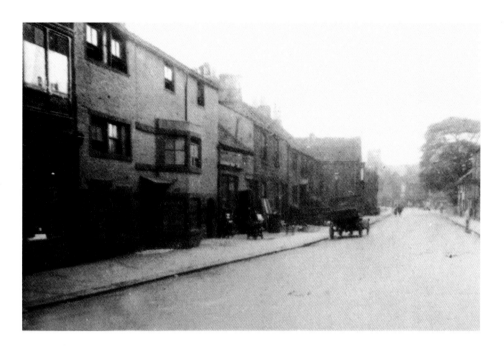

Model Lodging House, Bondgate

From the turn of the century to its closure in 1948, the Model Lodging House on Bondgate provided cheap accommodation for anyone doing temporary work in the area. Arthur Lee, the keeper for many years, charged 4d (about 2p) a night in a dormitory and had a small shop selling essentials. Touring German bands stayed there with organ grinders and their monkeys, as did Italians with dancing bears. It was also a permanent home to local characters, such as Old Mothballs and Polly Nowt. The property was owned by Ted Smith when demolished in 1961 and his shop still occupies most of the remaining buildings.

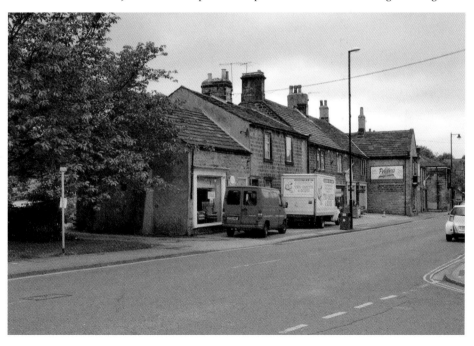

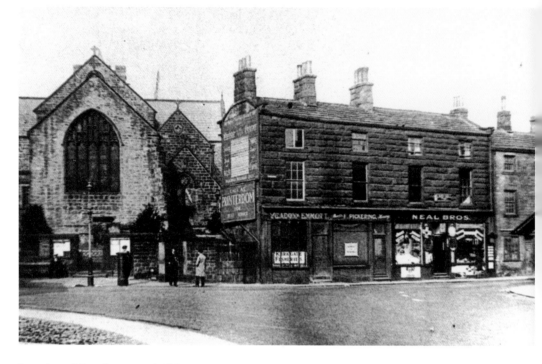

Junction of Bondsgate and Kirksgate, *c.* 1925

The figures in the photograph stand next to the gents' urinal near the church wall, adjacent to a fish and chip shop. The most striking change is the demolition of the building in front of the church in 1933. This took place after some fifteen years of planning, which began after the First World War with the purchase of some of the properties by a few local benefactors. These were sold to the council without profit when the council purchased the last of the properties. The local firm of F. W. Barker won the contract for demolition.

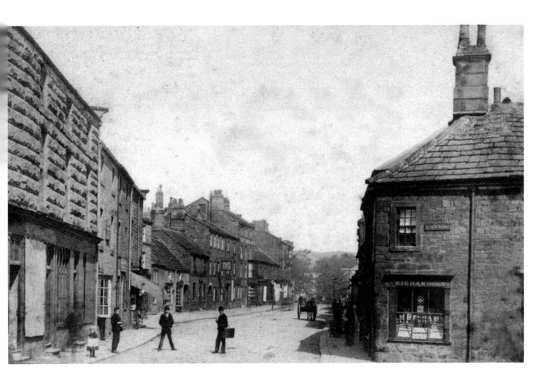

Kirkgate, c. 1889

Looking down Kirkgate at its junction with Bondgate, around 1889. The buildings in front of the church make the road look narrower than it does now. The corner shop of Robert Richardson, grocer, is on a sharp-angled corner; this was changed when plans were approved in 1923 for the present building with a rounded shopfront.

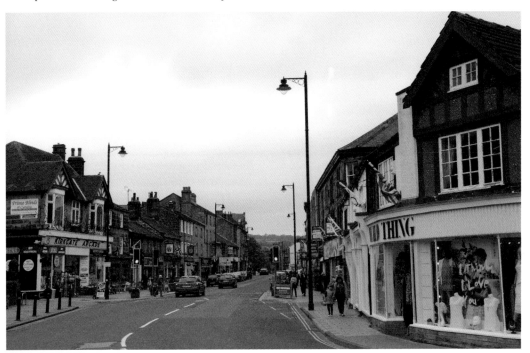

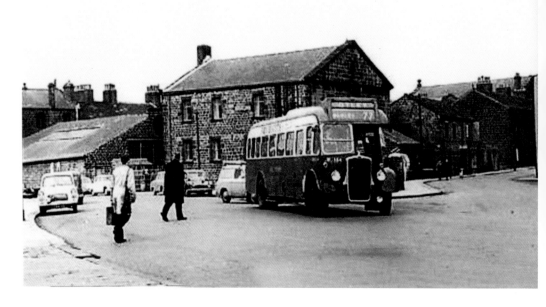

Bus Station, 1960s

A bus pulls into the bus station from Crossgate in the 1960s. In the background is the Nelson Street methodist chapel, first registered as a place of public worship in November 1771. John Wesley preached there in 1772. Along with the low-roofed building behind, it was later used as the drill hall, which was bought by the Yorkshire Territorial Army Association before the First World War and used in the Second World War as the Home Guard HQ. The bus station opened in 1939 and the drill hall was demolished in 1973.

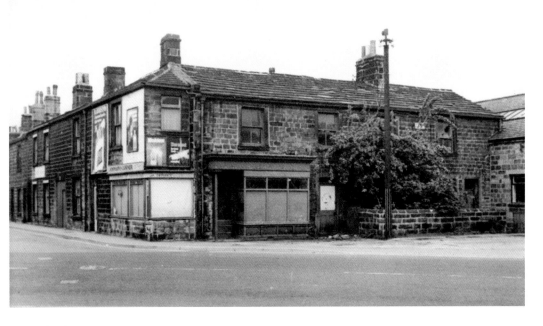

Charles Street

The east side of Charles Street, prior to demolition in 1972/73. The sign above the shop says 'Johnson's Corner'. Johnson's were general grocers. The new telephone exchange was opened in 1979. The old exchange was on the top floor of the post office building on Nelson Street. Before that it was on Kirkgate and then moved to the old vicarage on Church Lane in 1901, with telephone operators who connected customers manually. It became an automatic exchange in 1946.

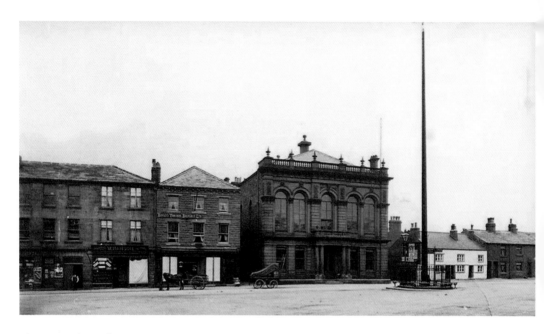

The Maypole and Cross Green

A postcard from around 1910 by George Brown of Otley entitled 'The Maypole and Cross Green'. The Mechanics Institute was opened in 1871 following the removal of four thatched cottages. It had a concert hall for 800 people, a lecture room for science and art classes, and a library. The white cottages on the right were cleared for new public toilets in the 1960s; they were later demolished and new houses were built. The maypole was struck by lightning in 1871, but was later replaced, and the present one was erected in 2004.

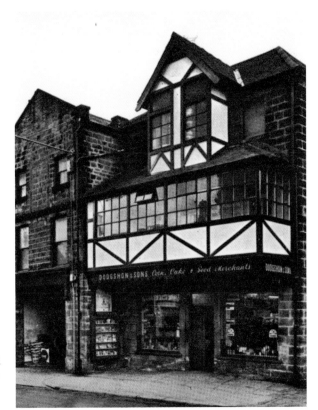

Dodgshon's Mill Shop, Clapgate
Elisha Dodgshon founded the
business in 1880, when ships,
trains, barges and horses were
used to bring cereals, oilcakes and
other ingredients to the mills in
Otley to be converted into animal
feed. In 1886, Otley architect Alfred
Marshall planned the alterations to
the shop, including the canopied
and galleried frontage.

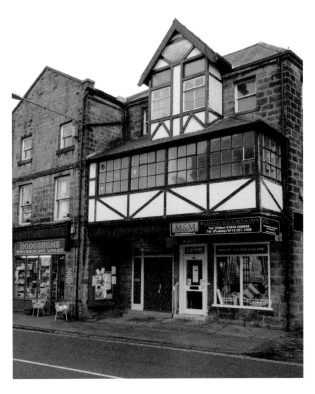

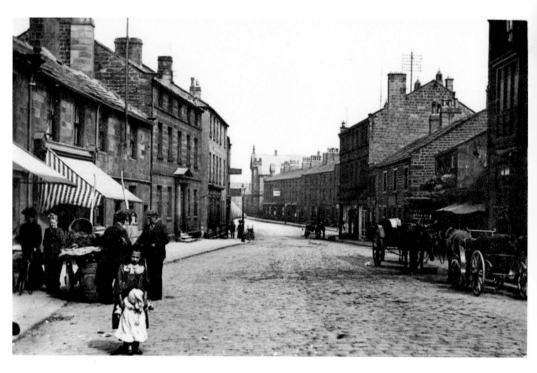

Boroughgate, Looking East from Market Place, c. 1910
Look carefully on the left and you can see two men on the roof! Boroughgate is the ancient name for the principal thoroughfare of the town, although it looks very quiet in 1910 compared to the present, with people standing in the road and even posing for the photographer.

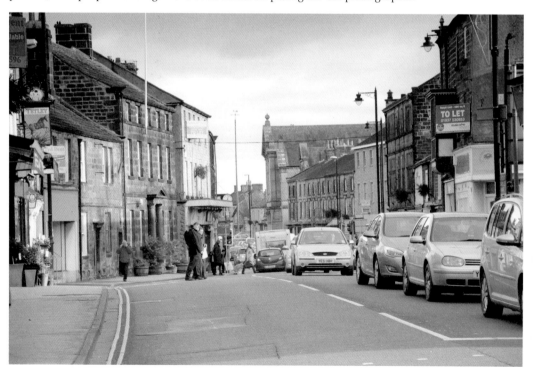

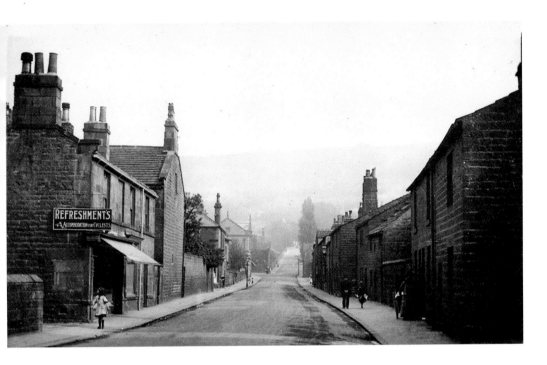

Gay Lane, 1905

The name of this lane is said to be a combination of Norse words *giel* and *gil*, meaning a narrow valley. The refreshments sign is for Charlie Hardisty's café, which offered accommodation for cyclists; cycling was popular in the early 1900s. John Elliott's Steel Croft machine works was situated beyond the houses on the right. Dawson, Payne and Elliott made Otley famous for their machines, which were exported all over the world.

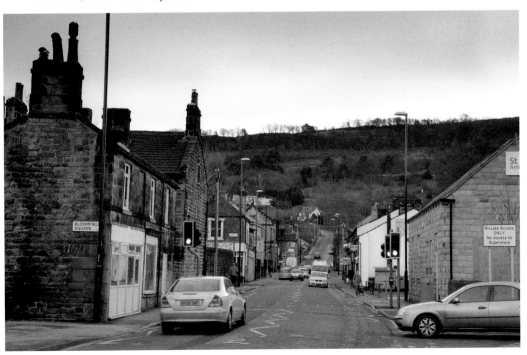

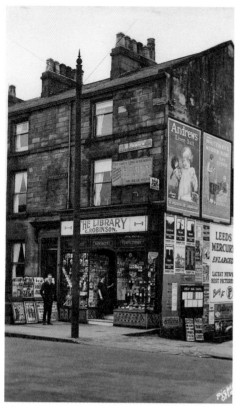

The Library, Ashfield Place, 1936

Here we see Ashfield Place in 1936, with 'The Library' newsagent's owned by Charlie Robinson. There were also branches on Gay Lane and Farnley Lane, and he had a lending library of 4,000 books to deliver on a handcart; that same cart picked up the newspapers early in the mornings at the railway station too. Also on sale were picture postcards, guidebooks and an up-to-date stock of music, as well as tobacco, tea and a random assortment of goods, such as metal polish, ink, sweets, liver-salts and tonics to combat rheumatism and gout! The shop is now a private house.

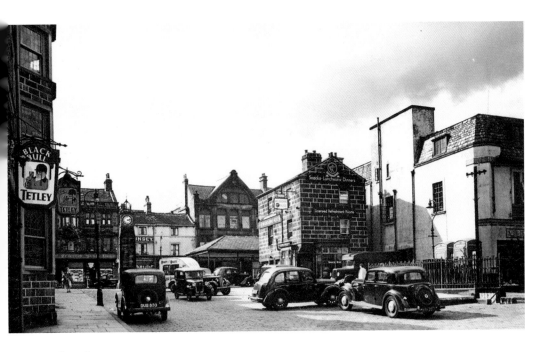

Market Place, 1952

The Market Place, 1952, with the Black Bull (Otley's oldest surviving pub), New Inn and Leeds House. The Black Bull is now the only surviving pub. Moss's store is on the right and in front of the shop, the iron railings led down to the underground public toilets. The Jubilee Clock was erected in 1888 to celebrate Queen Victoria's fifty years on the throne.

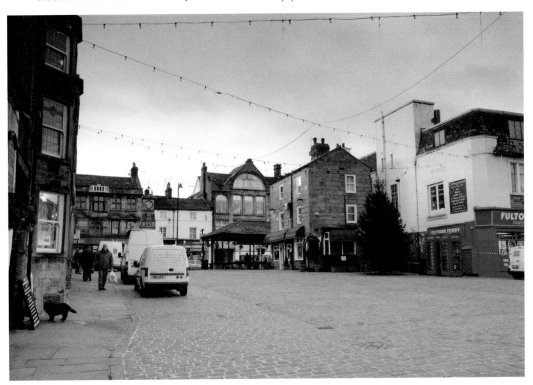

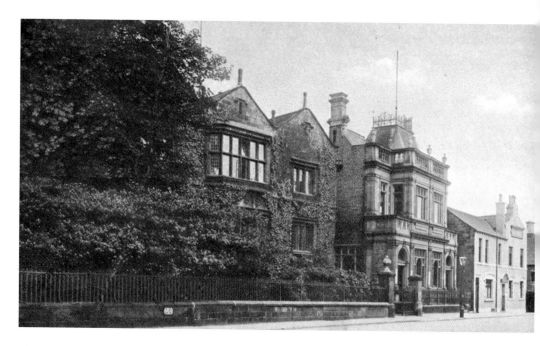

The Old Grammar School

The old grammar school was founded in 1611 and named after Prince Henry who was Prince of Wales. The founder, Thomas Cave, left money for the school, which was originally a one-storey building. This was taken down and the present one was built from the old materials. It then reopened in 1840, but closed in 1874 due to a lack of funds. Later it was used by Henry Dacre, a solicitor, and the deputy steward of the Manor of Otley. On the right was the Craven Bank and the Royal Oak. The statue in the modern photograph is of Thomas Chippendale, the famous Otley cabinetmaker and furniture designer. It was unveiled in 1987.

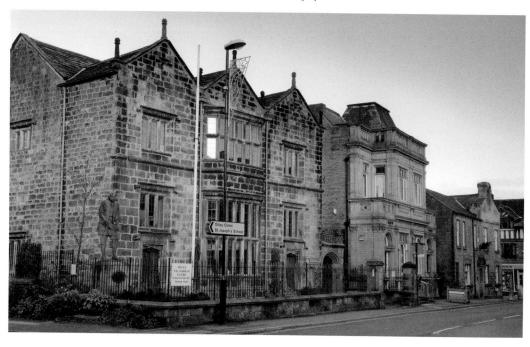

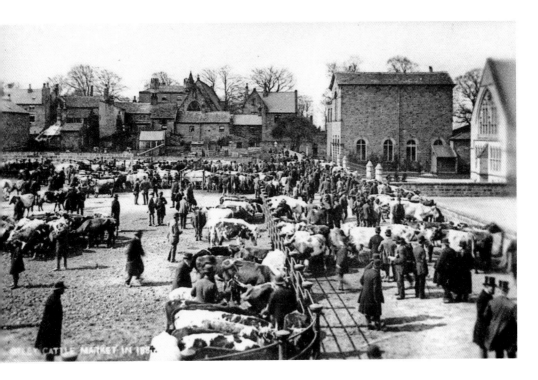

Licks Cattle Market, 1884

Before 1884, cattle had been sold at Cross Green and Manor Square. The charter for Otley market dates back almost 800 years to Henry III, and cattle were sold in the streets in the early days. In 1885, the Otley local board imposed a fine of 40s (about £150 in today's money) for selling cattle in the street. A local anecdote suggests the name 'Licks' is said to come from the blocks of salt hung from the pens for the cattle to lick, but its original meaning is 'stream' from the old English 'licc'.

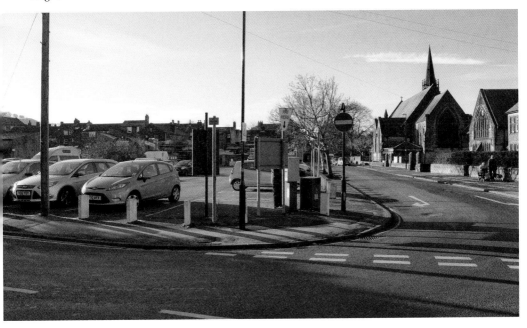

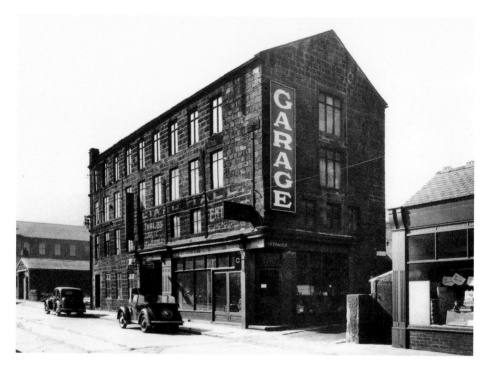

Lawson's Tannery Building, Station Road, Early 1950s
According to the sign, the ground-floor shop and garage was being used by 'Arthur Kitching. M. I. M. I. Motor Engineer, Repairs Tel 2427'. The first floor was sublet as a billiard hall with five tables. This building was later demolished and Kitching's had a new car showroom and garage built, which was eventually replaced by the houses in the new photograph.

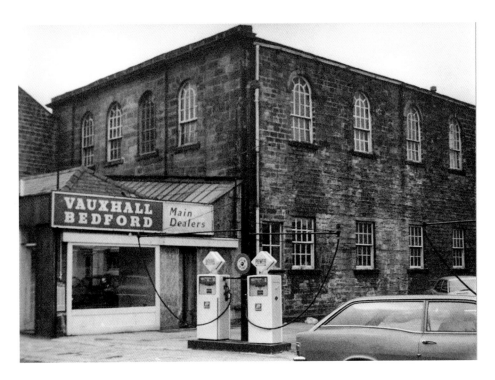

Jackson's Garage, 1968

The showroom is attached to the Wesleyan chapel, built in 1826 for the growing Methodist church congregations in Otley. It closed in 1876, but was used as a Sunday school until it was sold to W. B. Moss for use as a grocery warehouse for his shop in the Market Place. The showroom was added in 1906. The building was converted into the Chevin Court retirement apartments in 1992. You can still see the roofline of the car showroom as a diagonal line on the new building.

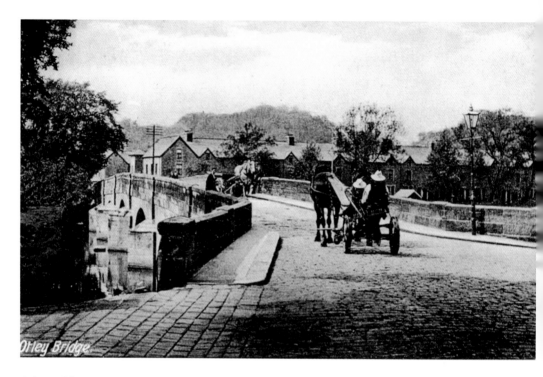

Otley Bridge, c. 1917

A postcard, postmarked 1917, by Jackson's of Bradford shows a quiet scene as the horses walk slowly over the bridge. The roadway is narrow due to the footpaths on either side of the road. In the modern photograph, a horse causes traffic queues as it crosses the bridge, but the pedestrians have a walkway, which was attached to the side of the bridge in 1957.

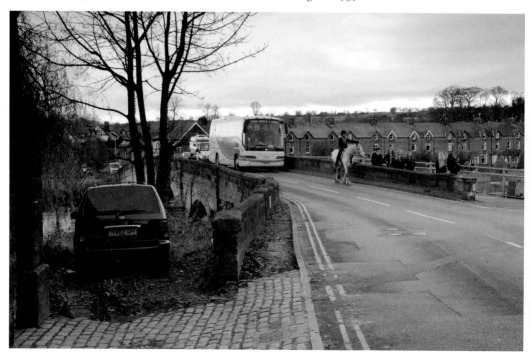

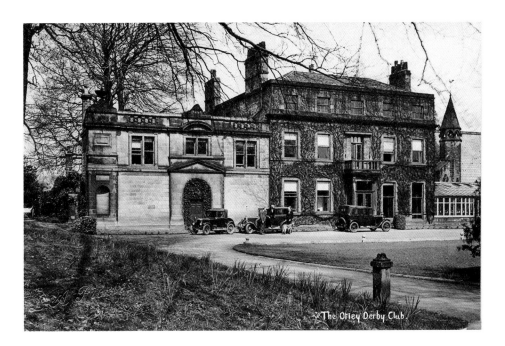

Manor House, 1932

Built by the attorney Matthew Wilson in 1784, the manor house was later occupied by Thomas Constable, who built the Catholic church on the right in 1851. After his death in 1891, his daughter lived there until 1961. The house was converted into flats in the late 1970s. The Derby Club in the photograph's title refers to a lottery that was run from a tenancy in the house; unfortunately, it was illegal and was brought to an end in 1933, with the directors being fined £500 each!

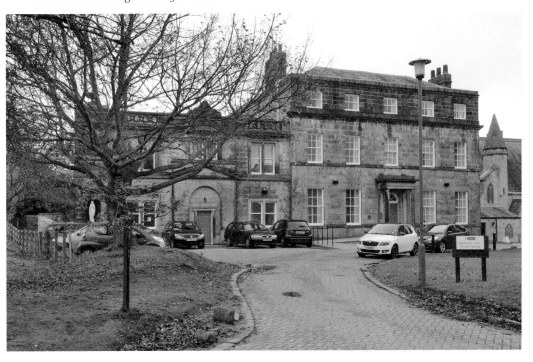

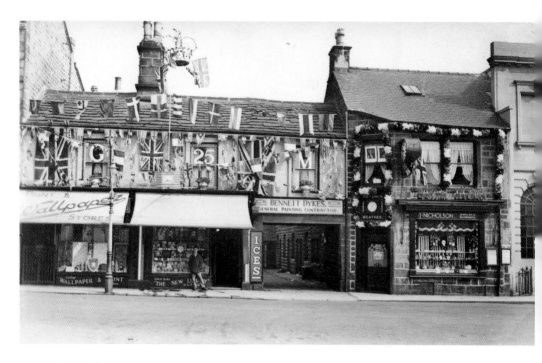

Boroughgate Shops, 1935

Shops in Boroughgate, decorated for the celebration of George V's Silver Jubilee in 1935, included Bennett and Dykes' wallpaper shop, Frank Cliffe's Chocolate Box and the yard for Nos 20 to 30 Boroughgate. Joseph Nicholson, the jeweller, was the official timekeeper in Otley, and the family had the job since 1871. In the museum, there is a photograph of Joseph next to the Jubilee Clock in the Market Place holding the winding key. The clock hanging above the shop was said to be the most accurate in Otley, and was usefully situated opposite the bus station. The shops were cleared in the early 1980s to extend the Otley Building Society (now the Skipton).

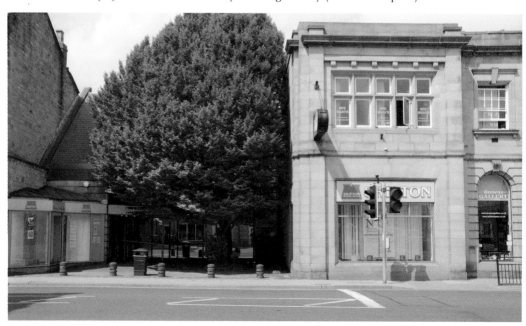

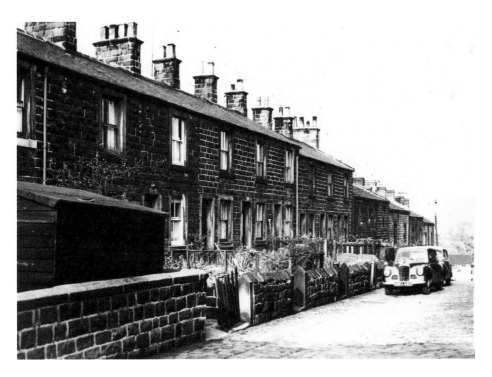

Union Street, 1962
These houses overlooked the printing machine engineering works of Dawson, Payne and Elliott between Burras Lane and Westgate. They were all demolished in 1968 to build the sheltered homes known as Union Court Flats.

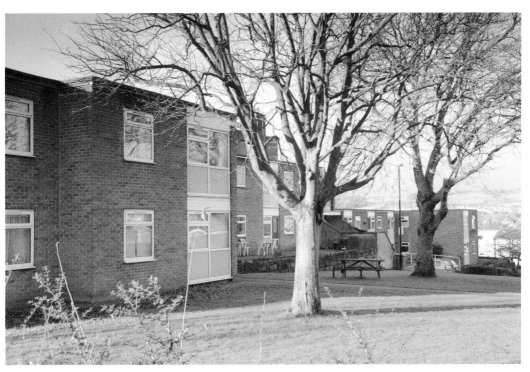

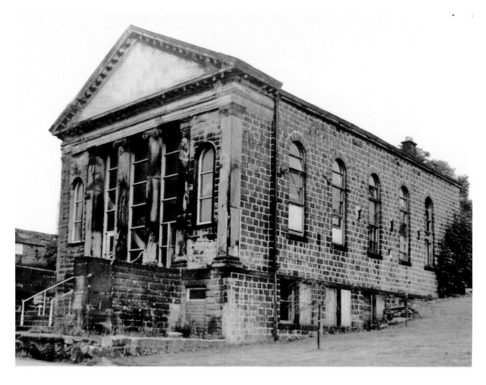

Westgate Methodist New Connexion Chapel

This chapel was built in 1857 and used until 1944. It was later used for various businesses, including a children's clothing factory in the 1950s, before demolition in 1970. The congregation, also known as the United Methodists, later joined the Methodist church in Station Road. The recreation hall was behind the chapel with access from Church Lane.

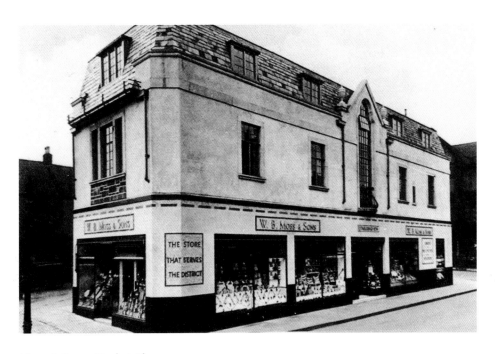

Moss & Sons, Market Place, 1930
Originally, this shop was called the Beehive Store, owned by Stephen Parkinson of Otley. In 1892, he sold it to Mr W. B. Moss of Hitchen, Hertfordshire, who, along with his sons, had stores locally in Ripon and Knaresborough, and as far south as Welwyn and Letchworth. This photograph above is from 1930 after it was extended and rebuilt.

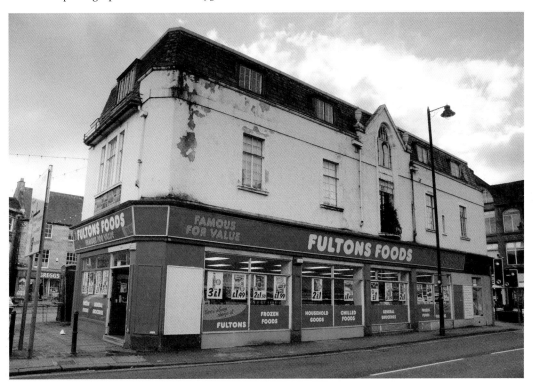

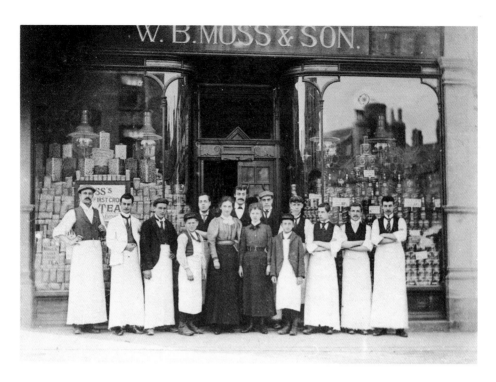

W. B. Moss & Son

Looking very smart in their uniforms, the staff of W. B. Moss & Son pose outside their store. Note the smart lamps and beautiful curved glass window with an array of goods for sale. This shop was managed by William Harry Moss, the eldest of the Moss sons, who married the daughter of a Mr Tetley, who managed the Otley woolen mill. He was also a Methodist lay preacher, known to be strict but fair with his staff. Moss & Son's delivered groceries by bicycle and customers had a week's credit, making the shop very popular.

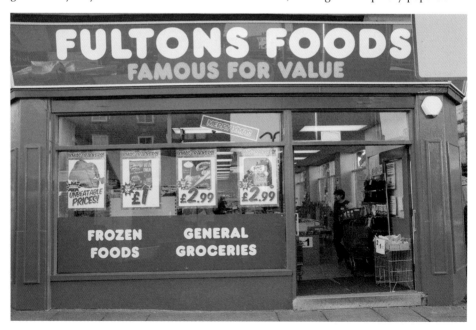

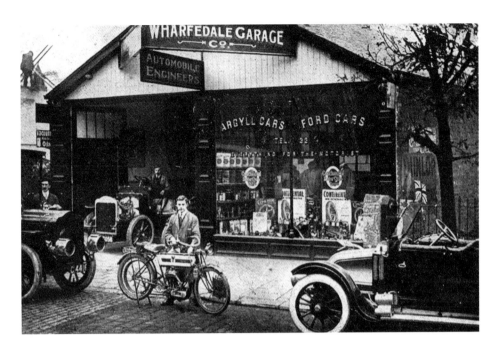

Wharfedale Garage & Co., Westgate

Frank Hargreaves was the proprietor at the time of this photograph and his apprentice was Ivan King who, with his older brothers Hedley and Gerald, founded the firm King Brothers just after the First World War, and took over these premises. Gerald was a pilot in the Royal Flying Corps in the First World War; he also trained pilots and was president of Otley Air Training Corps. They were the sons of A. J. King, the Otley postmaster, from 1911 to 1924. This garage was renamed Manor Garage and they also had a garage in Cross Green, near the rugby club. The three brothers produced a sports car in 1933, said to be the first car of its type designed and produced in the district. Ivan King retired as managing director in 1970, and G. Eric Hunt of Bramhope took over the garage, which is currently a carpet shop.

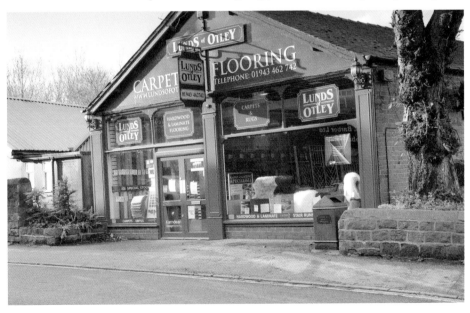

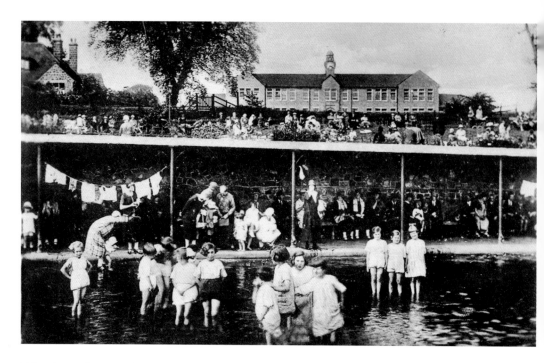

Wharfemeadows Park

The paddling pool in Wharfemeadows Park, from a postcard dated 1938. The park was opened On 26 July 1924 by A. Greenwood MP, secretary to the Minister of Health, and Major F. H. Fawkes of Farnley Hall, the donor of a very large part of the site. In the background is Prince Henrys' Grammar School, opened on this site in 1925, after the old grammar school in Manor Square closed in 1874. You can just see the school clock in the new photograph.

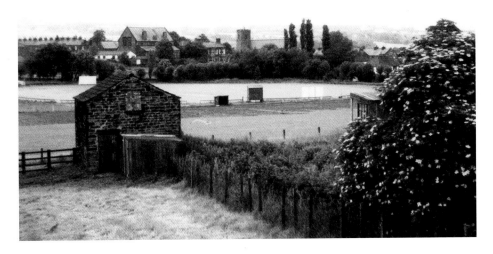

Dawson, Payne and Elliott's Sports Ground

A photograph of Dawson, Payne and Elliott's sports ground, taken from the site of the old railway goods yard in 1971, looking over an old barn across the cricket pitch towards Burras Lane, with the parish church tower and vicarage to its left. The large building to the left of the vicarage is the 1881 Burras Lane Sunday school and church hall, also used at one time as the youth club. It can just be seen (*centre-left*) in the new photograph with its extension, which was built when it was converted into town houses in 1999. This area, including the cricket pitch, became a housing development in the 1970s.

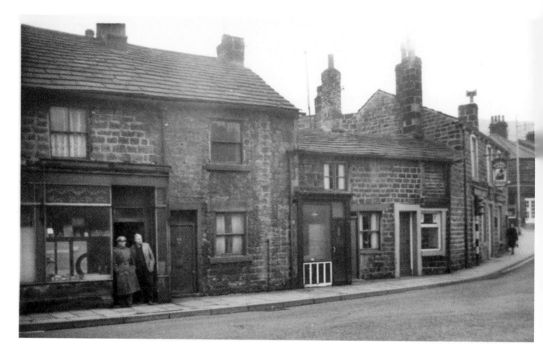

Top of Westgate, Late 1960s

The pub is the Mason's Arms, with the traffic lights in front, as this was a busy junction where the roads from Ilkley and Bradford met before the bypass was built in the 1980s. The shop belongs to George Chew, who sold motorcycle parts and, along with his brother Leslie (standing on the right), he had a domestic garage on West Chevin Road, from where they carried out repairs. It was a regular meeting place for Otley bikers when motorbikes gained popularity after the war. These buildings were demolished in 1971.

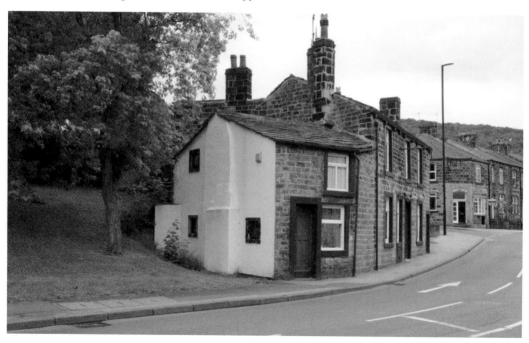

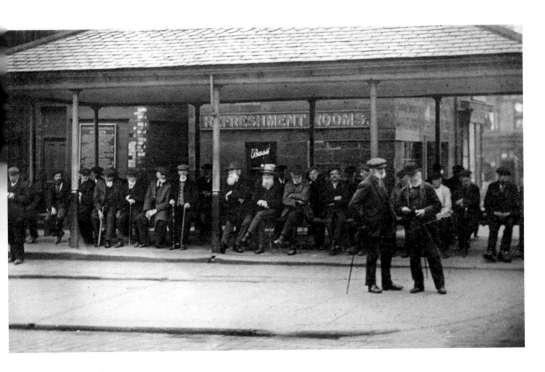

The Butter Cross, *c.* 1905

The 'old worthies', as they were often called, with their wonderful selection of beards and moustaches, pass the time talking and putting the world to rights. The refreshment rooms with the Bass sign behind ceased to be licensed in 1962, but is still currently a café. The other building behind on the left served the market stalls until it became part of Moss & Son's grocery shop.

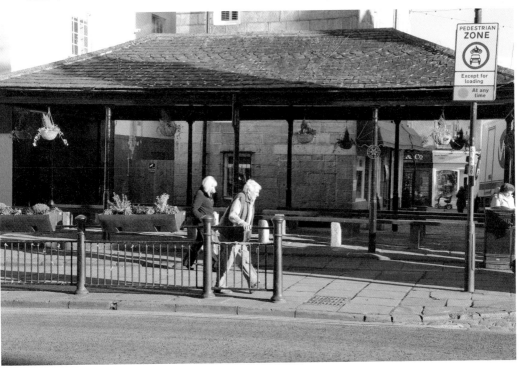

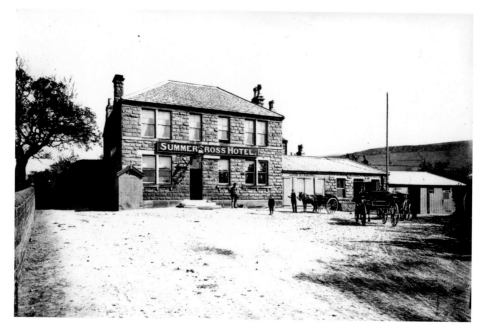

The Summer Cross, 1889

Opposite the cemetery lodge on Pool Road, the Summer Cross appears to have been converted into an inn around 1870, with the first known landlord being Ellis B. Hartley, and, due to its position, is likely to have been built to take advantage of the passing traffic on the Tadcaster Road turnpike. It seems to have been converted from at least three earlier buildings, which probably faced south (i.e. in the opposite direction). The bay windows were added later and the floors in the pub were famous for being on different levels. The pub is now closed and, like many Otley properties, awaits conversion or demolition.

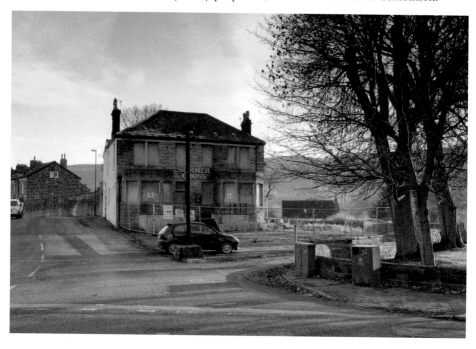

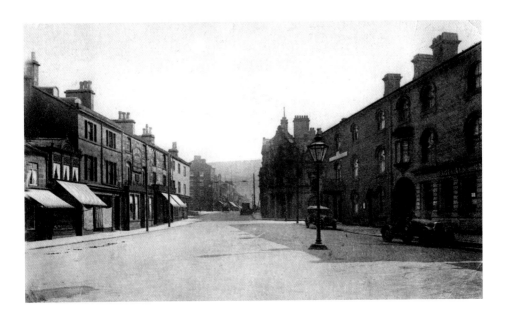

Manor Square, 1930

Manor Square has been known as 'post office square' and 'cattle market' in the past. It appears to be a peaceful, idyllic square with a lamp-post in the centre and a few classic cars parked in the area. The Blue Bell Inn is on the left, opposite the White Horse Hotel, with Barclays Bank, which has now moved a short distance to the left to occupy the White Horse premises. On VE Day at the end of the Second World War, the news was announced from the balcony of the White Horse.

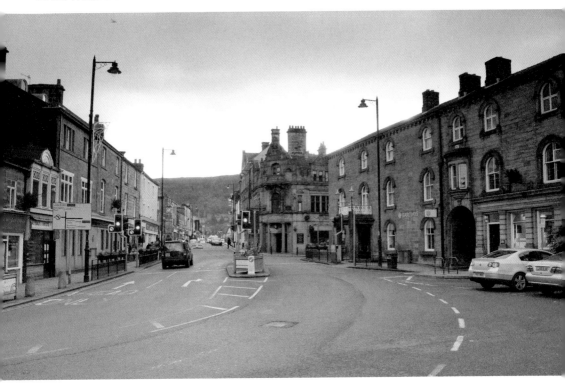

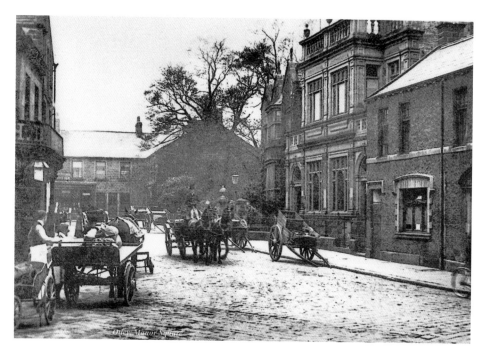

Clapgate, Looking West to Manor Square

In the old photograph, probably taken around 1900, there are only horse-drawn vehicles and carts at the roadside. The building on the left is Dodghson's Corn Mill, with sacks loaded onto a waiting cart. Notice that the carriage in the centre, which must belong to a well-to-do family, has a coachman with a uniform and a top hat!

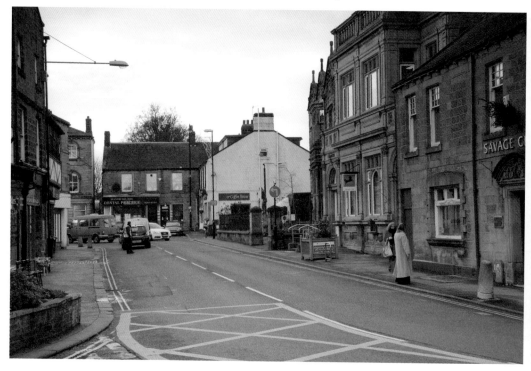

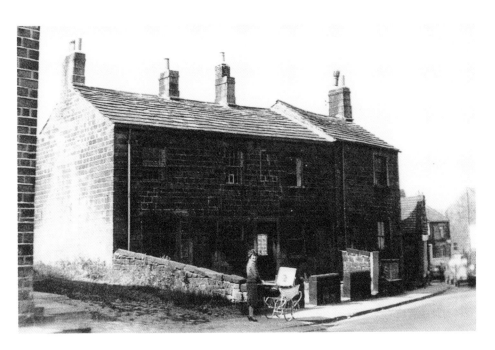

Piper Lane, Bradford Road, 1960s
Looking towards Westgate, the vehicles are at standstill at the Ilkley Road traffic lights next to the Fleece public house. All the buildings behind the lady with the pram were demolished, probably to improve the view at the junction.

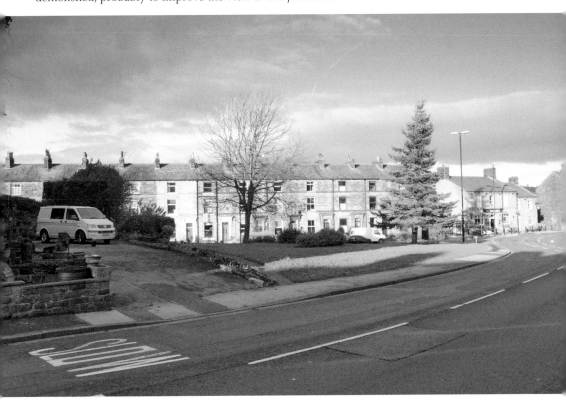

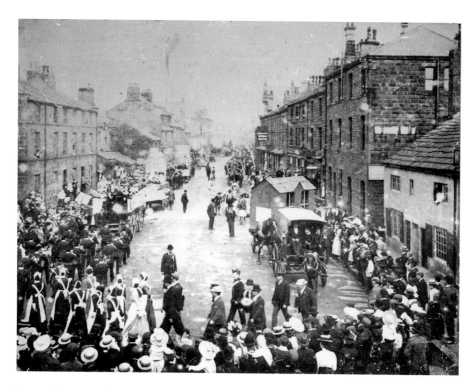

Boroughgate, Early 1900s

Here we see various floats of the Friendly Societies procession. The Otley Society was founded in the late 1890s, and raised money for local hospitals and charities until 1949, when it closed. The low building on the right was a pub, the Carpenters Arms, later renamed the Wharfedale Inn. It closed in 1907 and became refreshment rooms and lodgings. When it was demolished in October 1936, a coin dated 1806 was found in the walls, although the building is thought to be much older than that.

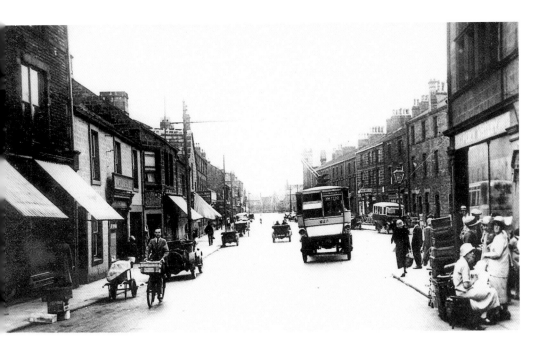

Boroughgate, Early 1920s

It is noticeable that the horse-drawn vehicles are no longer regularly seen, and cars and buses have replaced them. On the right, a trolleybus is coming towards us with the electric power cables overhead. The service started in 1915, coming from Guiseley; they turned round in Manchester Square around the maypole, which can just be seen in the distance, to run along Boroughgate, Westgate and Bradford Road back to Guiseley.

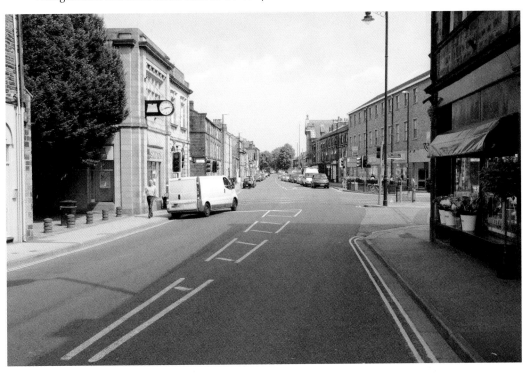

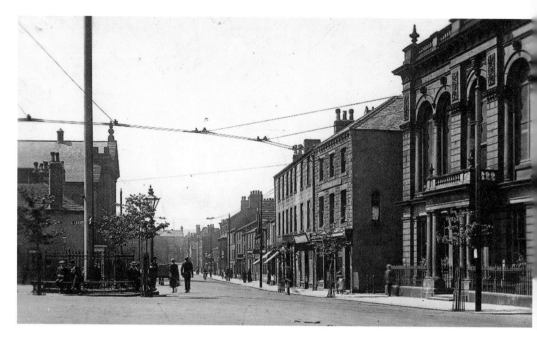

Cross Green, 1920s

Looking down Boroughgate in the 1920s, this shows the Mechanics Institute on the right with its iron railings, which were removed during the war, the maypole with seats around the base, and the overhead wires to enable the trolleybuses to turn around for the journey back to Guiseley. Trees were planted along Cross Green as part of a scheme to improve the streets of Otley around 1910. Francis Darwen of Creskeld Hall, Bramhope, was a generous contributor to the scheme, but turned down an offer to rename Cross Green 'Darwen Avenue', preferring the original name.

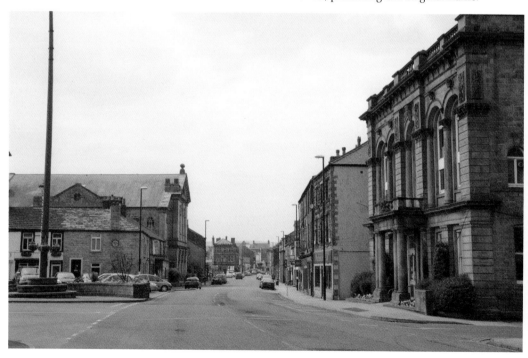

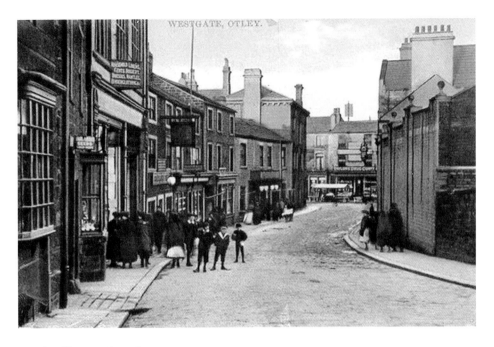

Beech Hill, a Section of Westgate, c. 1905
The figures on the left stand outside the Leeds Co-operative Society arcade, built in 1893 to replace their rented shops. Next to the arcade is the Half Moon Inn, the date of which is uncertain but which was a Masonic lodge from 1762. It is mentioned as one of twenty inns in the local records of 1882. On the right, behind the high wall, were the large stables for the Black Horse Hotel.

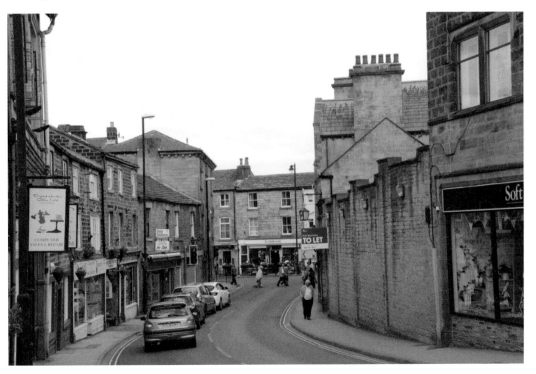

George Brown Photographer Studio, No. 20 Westgate, *c.* 1922

The photograph shows three early eighteenth-century cottages, one of which has been converted into the photographer's shop. It also shows the stone setts with which Beech Hill was paved in 1870, and the hanging shop sign suspended above Mr Brown's front door. He retired from business in 1960. In 1962, when the other properties became vacant, they were taken over, and alterations made to the interior by connecting all the properties together to make one.

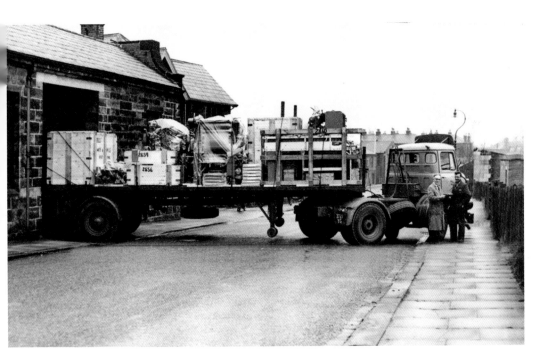

Falcon Works of Waite & Saville, Burras Lane, 1962
A lorry laden with printing machines leaving the Falcon Works of Waite & Saville on Burras Lane in 1962, on the way to an exhibition in Dusseldorf. The firm was one of the most inventive of the many printing machine manufacturers who made Otley world-famous from the 1870s. Founded in 1892, it closed in 1966.

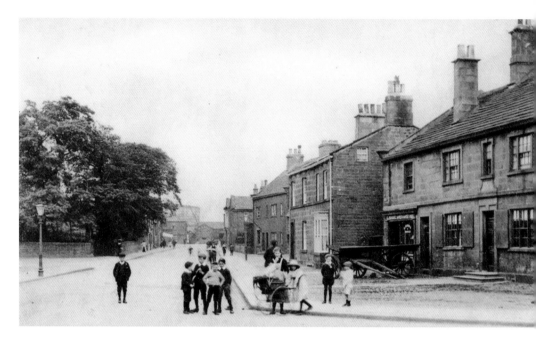

Bondgate, *c.* 1908

The children are posing for the photographer in front of No. 5, which has a date stone of 1753. The cart is outside the shop of George Moore, saddler and harness maker; behind the cart is the entrance to the yard of Lawson's Tannery. The tree-filled garden on the left is Grove House, now the memorial gardens.

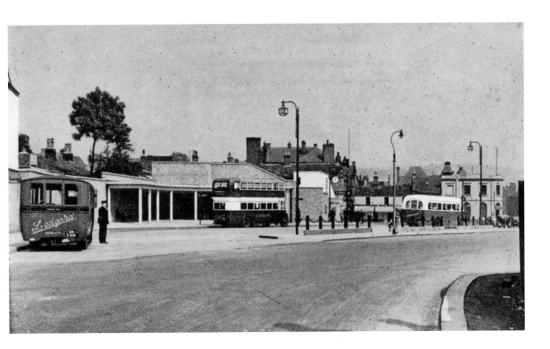

Otley Bus Station

Work started on the bus station in August 1938 after the area was cleared of houses and a large foundry. The demolition, which started in 1936, cleared a road through from Bondgate to Boroughgate. The bus station was first used on Sunday 26 March 1939, though there was no official opening; as the *Wharfedale Observer* reported, the first people knew of it was when buses started entering and leaving. Traffic congestion in the town was greatly eased due to buses not having to stop and pick up on the main streets. There were nearly 3,000 departures a week when it first opened.

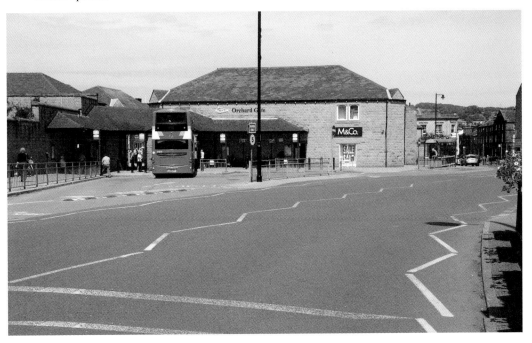

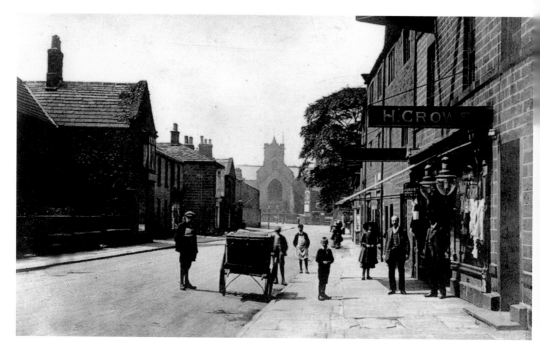

Bondgate, 1909

Outside the shop of H. Crowe Draper Outfitter and Stationer, the building was known as Bondgate House. The cart is one of the delivery carts from the post office. The eighteenth-century houses on the left were the Crofts and Quorn House. The Cock & Bottle public house (closed 1919) is further down on the right, and the Rose & Crown is on the corner.

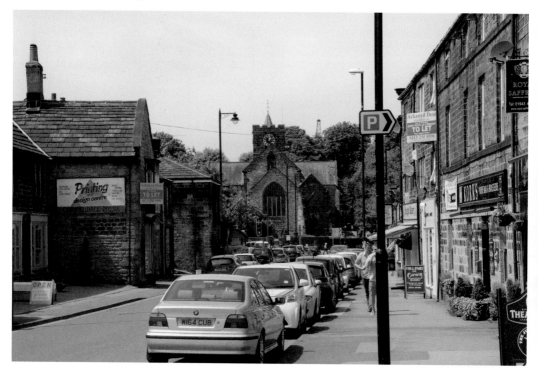

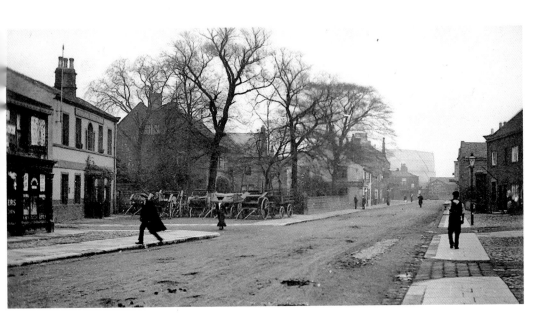

Bondgate, *c.* 1900

Bondgate, with the Bowling Green Inn on the left, the front being used to park carts. Built by Nathaniel Aked in 1757, it has been used as a courthouse, chapel and school. It was at one time called the Assembly Rooms, with an outside staircase leading to the upper floor that was used for concerts and dances. It was an inn from around 1825. At the time of this photograph, the landlord was James Ingham.

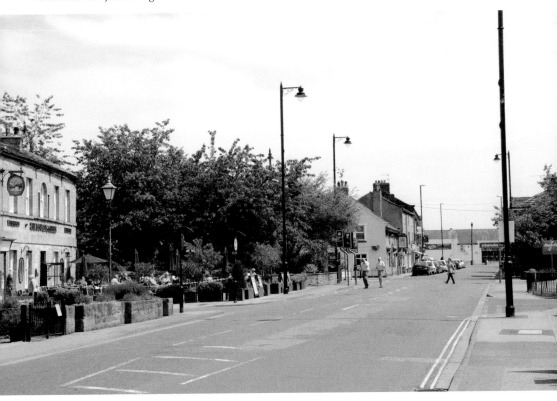

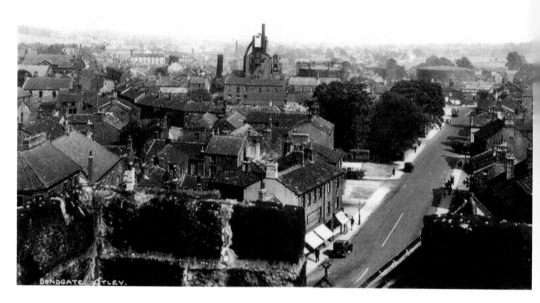

Looking Down Bondgate

This photograph looking down Bondgate was taken from the top of the church tower, and probably dates to the late 1920s or early 1930s as Grove House, with its trees still there before its demolition in 1935. The gasworks is very prominent in the centre, as are all the buildings cleared between 1936 and 1938 to make a road through to Boroughgate. At the top right, the Ford sign is on the roof of Annison Bull's garage and carriage works.

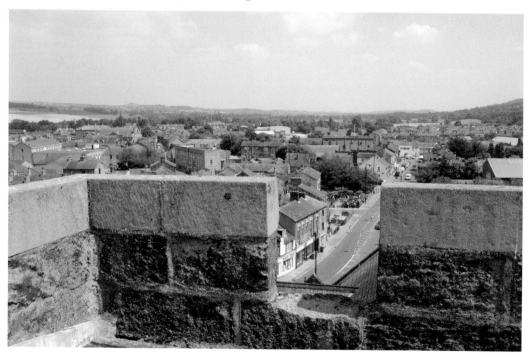

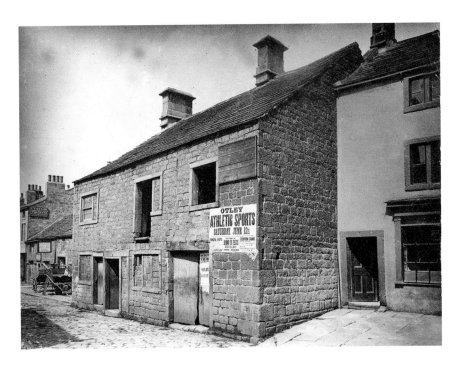

Top of Bridge Street, *c.* 1874

Formerly two cottages built in 1754 by William Gill on the site of Whitwam Barn, this old building jutted out into Bridge Street, and at the time of this photograph was used by James Mawson (corn dealer, miller and dealer in seeds) as stables and a warehouse for straw and cattle food. He later added a canopy in front of the building on the right-hand side, into which he spread his expanding business. The Three Horse Shoes Inn (rebuilt in 1873) is behind, and next door to it is the smithy with carts outside.

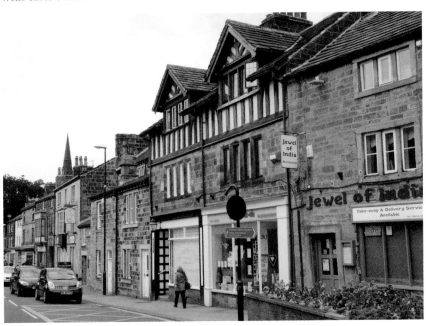

Crow Lane, 1985

This photograph was taken in 1985 in Crow Lane, the narrow street running behind and parallel to Cross Green and Pool Road. The buildings belong to Barker's Tannery, founded in 1850; they were demolished soon after the photograph was taken. It is one of over fifty photographs of Barker's held in Otley Museum, many showing the machinery and processes of the works. The covered bridge across the road joined two parts of the factory; the other part had access from Cross Green. Barker's was a major company in Otley, at its height employing over 100 people.

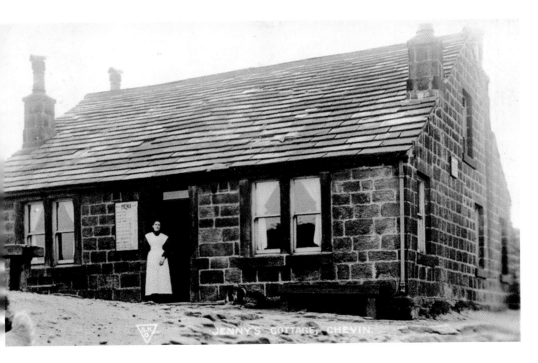

Jenny's Cottage, 1920

Jenny's Cottage (named after Jenny Myers, who lived there in the early nineteenth century) was on Otley Chevin, seen here in a postcard dated 1920. Hannah Blackburn stands in the doorway. She, along with her husband, a popular Otley character known as Senior Blackburn and a pork butcher by trade with a shop on Newmarket, lived in the isolated cottage on Beacon Hill at the top of the Chevin with their family. They ran the refreshment rooms for twenty-five years. The menu is on the wall and mentions ham, for which he won many prizes year after year at Otley Show. The house was demolished in 1976.

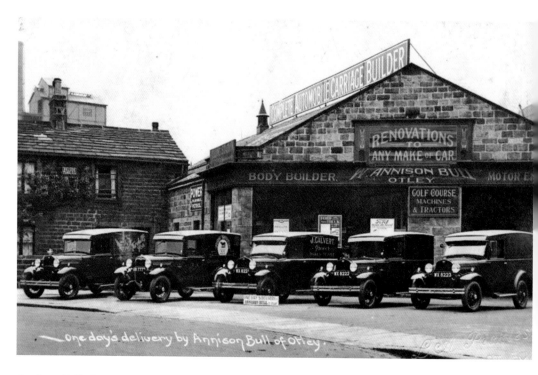

Annison Bull, Gay Lane, c. 1925
The company was established in 1897 and originally built various types of horse-drawn vehicles. The excellent workmanship of their carriages gave them a head start when motor cars became popular around the turn of the century. In 1912, they were approached by the Ford Motor Company and became one of their agents, building cars and trucks. They also designed and built a tractor called the 'Waboy'. The van on the left for Tordoff Tea has a miniature teapot on the bonnet.

Ilkley Road, 1959

This was a main road passing through Otley to Leeds from the west and, as can be seen from the photograph, was very dangerous for residents, many of whom would walk down to work at the Ackroyd's Mill and to Westgate School, which is still on that road today. The road was widened by the purchase of part of the Mill House garden in 1961, but it was still an area of major traffic congestion until the bypass was built in the mid-1980s. It is now an access only road and mainly used for residents' parking.

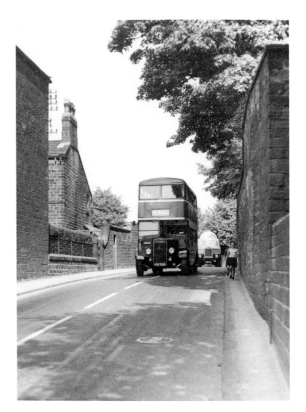

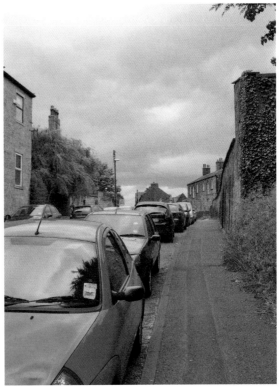

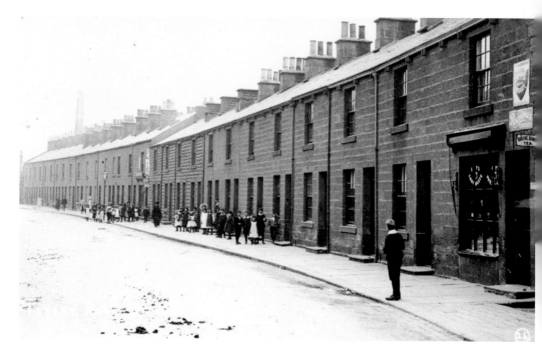

Ilkley Road, c. 1906
Pictured here, is the stretch of houses known as Peels Crescent, with the chimney of Duncans Mill in the background. Most of the residents worked at the worsted spinning mill and a school opposite catered for the children who worked part-time in the mill. There was a horn blower in the town who roused the millworkers at 5.30 a.m. to ensure they all went to work on time.

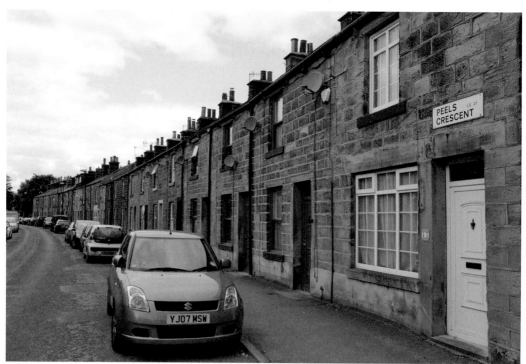

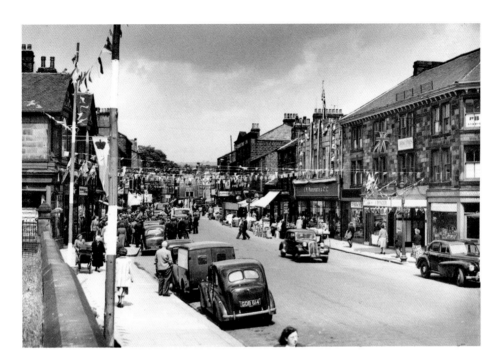

Kirkgate, 1953

Kirkgate decorated for the coronation of Queen Elizabeth. Woolworth's store is on the right. At the time, every town seemed to have a 'Woolies', but now this is no longer the case. The Picture House Cinema with its canopy is visible on the right. Further along the same side is the sign for the Queen's Head Inn, the actual date of which is unknown, but the building is dated 1744. It is famous for having first-floor stabling for horses to the rear, accessible by a ramp!

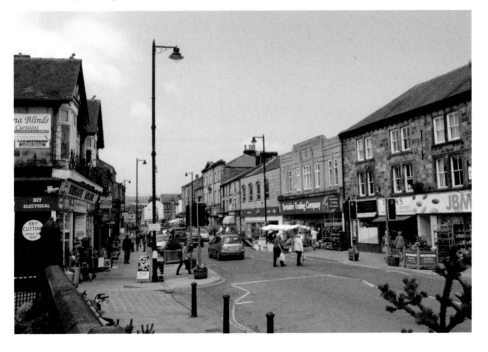

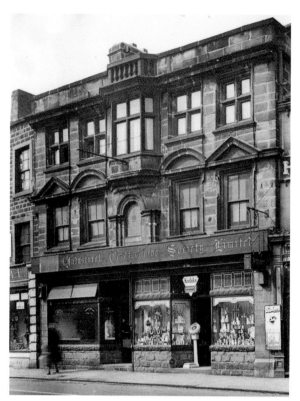

The Old Hall

This early Georgian residence was built around 1704 by the Barker family and was a house until the early 1840s. The original pillared front entrance was purchased by Doctor Thomas Shaw, who removed it for his house on Boroughgate, opposite the Market Place, later used as council offices. The ground floor of the Old Hall was then converted into shops, and at the time of this photograph, the Leeds Co-operative Society used the whole of the ground floor for their butchery and chemist departments. The upper floors have been used for accommodation, and it is said that the ghost of a man in a rocking chair has been seen in the bay window!

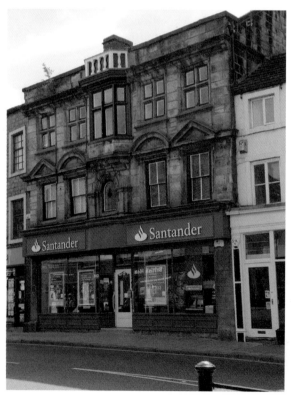

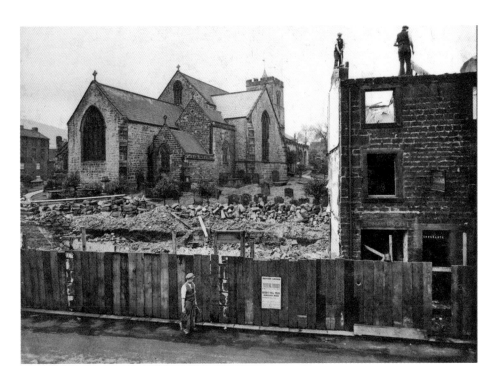

Parish Church, 1933

It is 1933, and the inhabitants of Otley see a view of the parish church that had been obscured for many years. The demolition of the seven properties by F. W. Barker is progressing well, but in a dangerous manner by present-day standards! The poster on the hoarding advertises a function at the Queen's Hall, formerly the recreation hall, which was just along Church Lane behind the building.

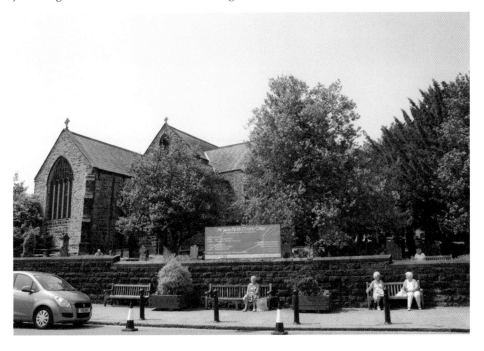

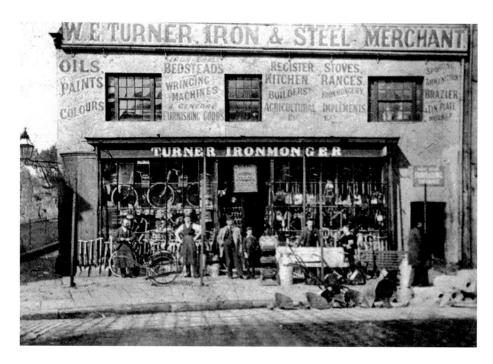

Turner's Ironmonger, Next to Church Lane

William Turner, steel merchant and founder, sold a vast array of goods in his shop, as can be seen in the photograph. This photograph was taken around 1880, before he moved further down Kirkgate to new premises opposite the Market Place in 1899 when Kirkgate Arcade was built. They also had a shop in Harrogate. There are examples of his wringing machines in the museum collection and a working Turner Range in a house in Guycroft.

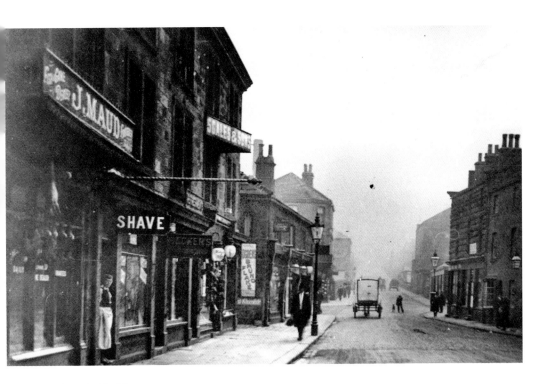

South End of Kirkgate, *c.* 1922

Joseph Maude at No. 40 was a fruit, fish and game dealer. Outside No. 42, Walter Houlton, the hairdresser and barber, waits for customers. No. 44 was owned by Nathan Secker, the confectioner, and at No. 46 was Scales & Son, the boot dealer. A horse-drawn wagon moves down the street, past a man and his dog standing nonchalantly in the middle of the road.

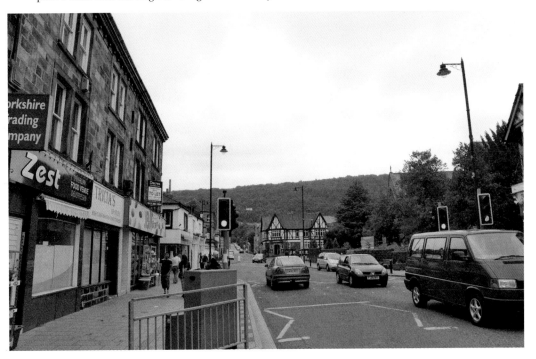

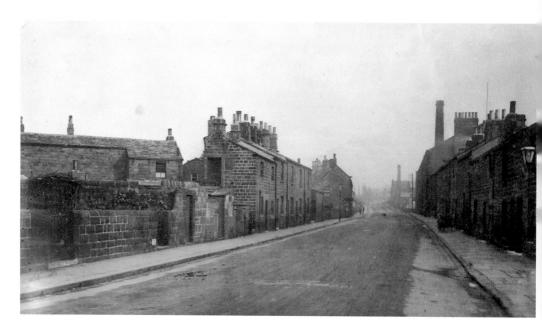

Leeds Road

Leeds Road disappears into the distance, looking east. The new road was opened in 1842 at a cost of £14,000. Records show a Mr George Lee was paid £5 and 19s for damage to his fruit trees by the builders. The tall chimney on the right in the distance is John Kelley's Albion works, which made Wharfedale printing machines between 1889 and 1905.

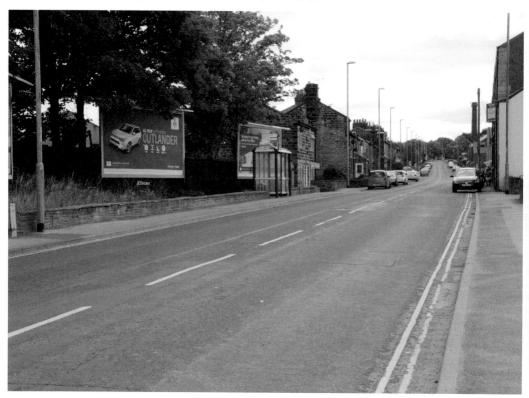

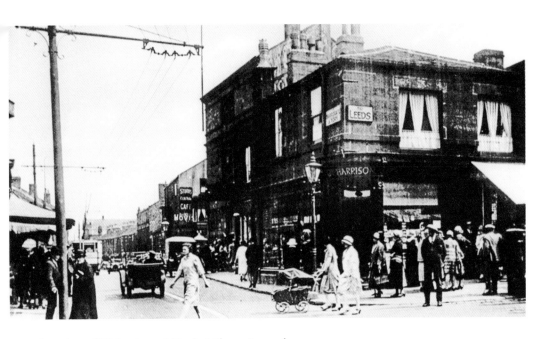

Junction of Kirkgate and Market Place, Around 1920
Motor transport had just about replaced horse-drawn vehicles by this time. A trolleybus can be seen heading along Boroughgate. These vehicles, first seen in Otley in 1915, were known as the yellow perils.

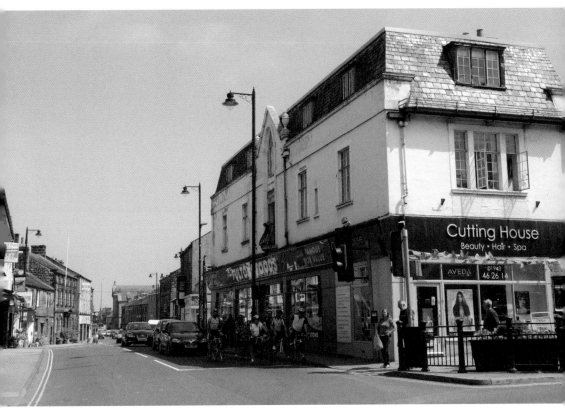

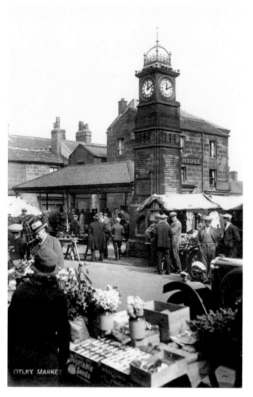

Market Day, 1928
Dated 1928, this photograph taken on market day has the Jubilee Clock showing ten past twelve (on both photographs!), with the stalls on the Market Place as well as on Kirkgate. A car is passing on the right and a horse and cart on the left. Traffic has always been a problem on market days, and a one-way system and the closure of Kirkgate for the day has often been proposed but never actually instigated.

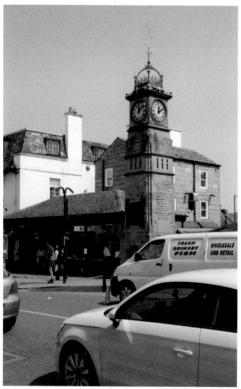

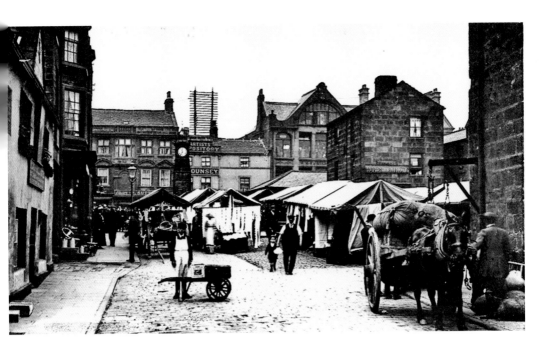

Market Day, 1900

A cart with wool sacks unloads on the corner of No. 28, using a crane. A youth with a handcart poses for the photographer. Above the roof in the centre, the frame for the wires for the telephone exchange in Henry Mounsey's Kirkgate shop heralds the new technology at the turn of the century, while the market traders sell their goods as they have done in the town for hundreds of years.

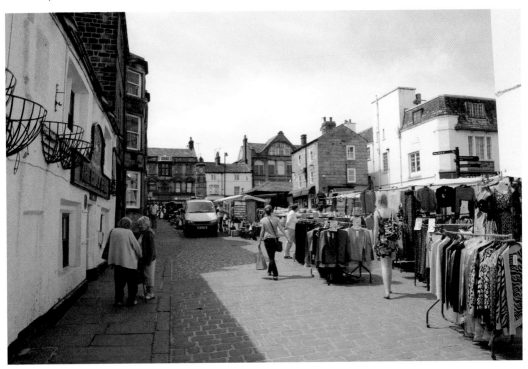

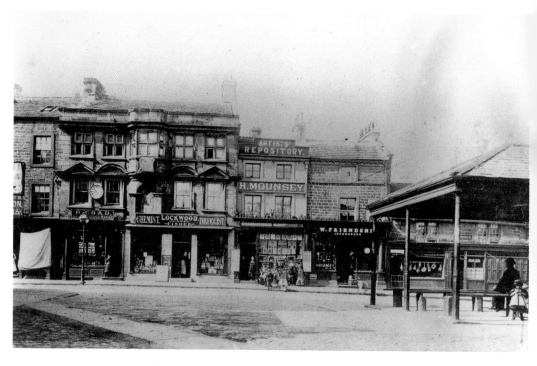

Market Place and Kirkgate

The Market Place and Kirkgate before the Jubilee Clock was erected in 1888. The Old Hall had two shops on the ground floor at this time: Richard Coad, the clockmaker, and Thomas Lockwood, the chemist, next to Mounsey's, the stationer's, who are still trading in the town. Thomas Rhodes, the tallow chandler and candlemaker, is the last shop after the ironmonger and butcher.

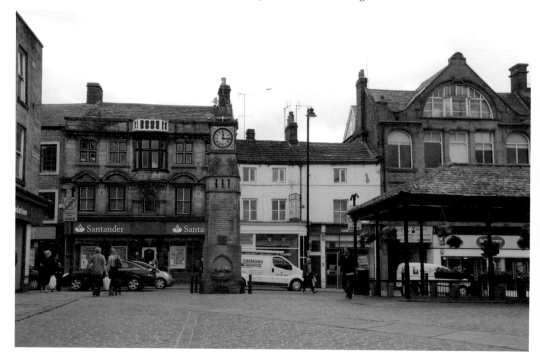

**The Bay Horse Yard and Passage,
c. 1930**
Probably the most frequented
thoroughfare in Otley, linking Bridge
Street and the Market Place. The actual
pathway is an ancient way between the
medieval burgage plots, probably dating
back to the thirteenth century, with
the eighteenth- and nineteenth-century
buildings erected following the old
layout. The rear of the Bay Horse Hotel is
advertised on the gable of the cottage. The
yard contained houses and refreshment
rooms up to around 1930, and still has a
few shops and a restaurant.

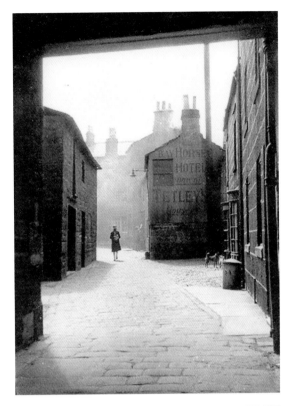

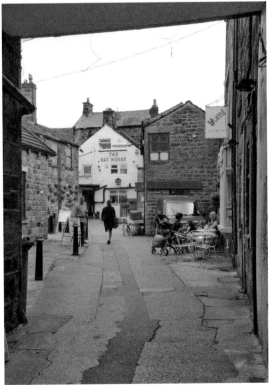

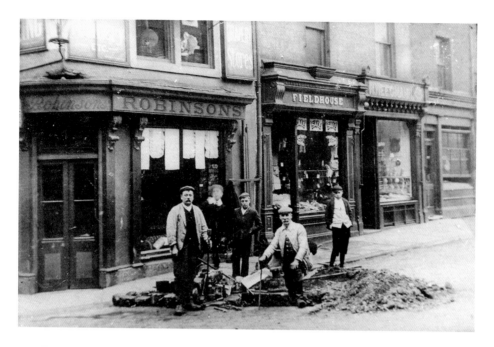

Number 2 Market Place

Workmen pose by a hole at the corner of Market Place, outside No. 2, Robinson's drapery shop. You can see the stone setts stacked next to them. No. 4 is Fieldhouse, the milliner, and next is Weegman, the butcher, who has now also taken over No. 4. Weegman's was founded around 1870 by Wilhelm Weegman, who came to England from Wurtemburg, Germany, in 1863. The Weegmans were well-respected in the town and known for their generosity to those in need.

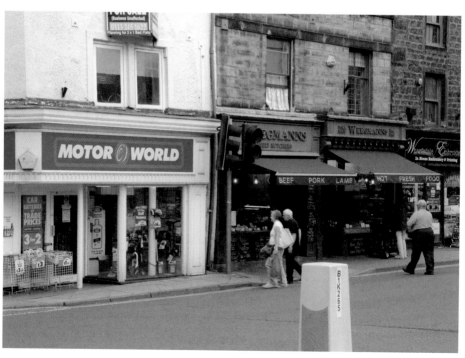

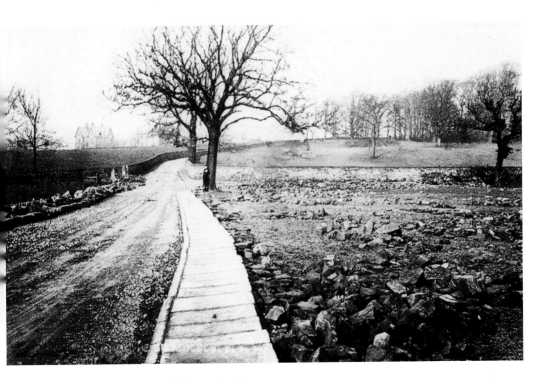

Newall Carr Road From Bridge End, 1883

The old photograph was taken in 1883, just after the great flood which occurred that year. At this time, the area was known as the Klondike, before the houses were built on Bridge Avenue and Farnley Lane. Billams Hill is also just a lane leading up to Newall and Weston. The only houses are Newall Hall on the right and, in the far distance on Weston Lane, two large houses – 'Belmont' on the left and 'Newall Close' on the right.

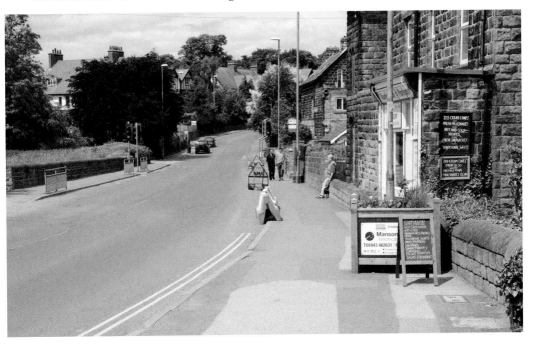

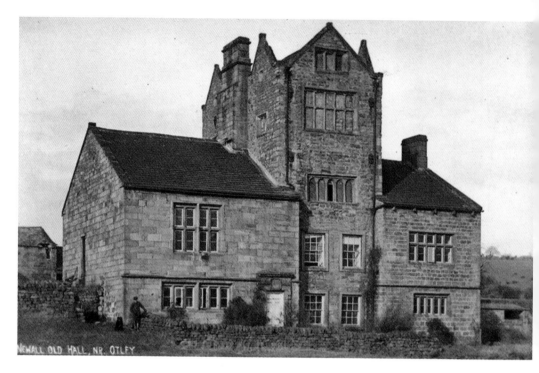

Newall Old Hall

Newall Old Hall was demolished in 1925 when the Sunday school and council housing estate were built. It was originally established by the Keighley family around 1300 as a much bigger house. The tower remains in this photograph, the only old part of the building, as the cottages on either side were built in 1827. It was a tenanted farm in later years, the last tenant being Thomas Wood.

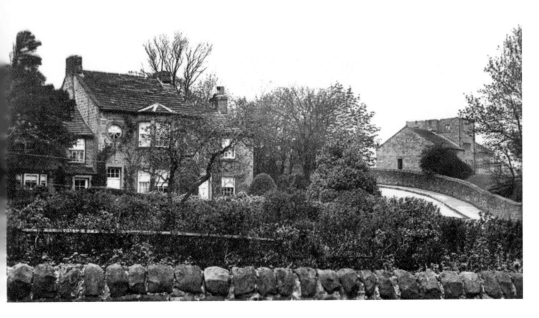

Dawson's Farm, Newall, c. 1920
Dawson's was also known as Yew Tree Farm at some point, hence the name of the pub. The date of the original building is not known, but the central section was believed to be from the seventeenth century. It reopened in 1970 as a public house, keeping many of the original features. Newall Old Hall can be seen on the right, with the top half of the tower removed.

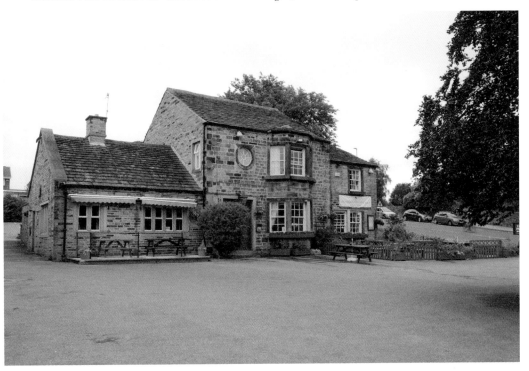

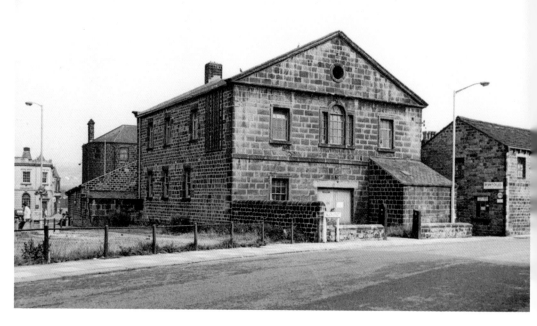

The Drill Hall

The Drill Hall, as it was known at the time of this photograph, was originally the Methodist Nelson Street chapel, first used in 1771. After use as a drill hall, it was virtually unused for many years and became dilapidated; it was finally demolished in 1973, along with part of the building behind on Boroughgate, to make way for a supermarket. A bank stands where the chapel was situated and the rough ground at the side, which was used for parking buses, is now a garden.

Church Entrance, Kirkgate, 1909
The entrance to the church on Kirkgate in 1909, before the demolition of the buildings on the left. This shows the wedding of Angela Garnett, whose family owned the papermaking factory beside the river, opposite Wharfemeadows Park. At the time, Garnett's was one of the biggest employers in Otley, hence the large crowd. You can see the canopy of Jackson's Arcade on the right. The most noticeable difference in the new photograph is the number of trees now in the churchyard.

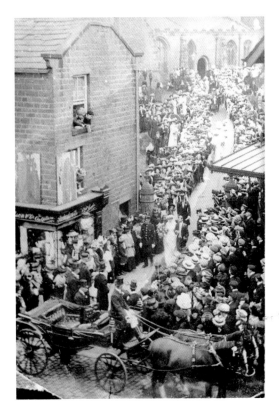

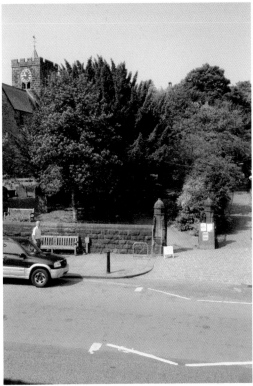

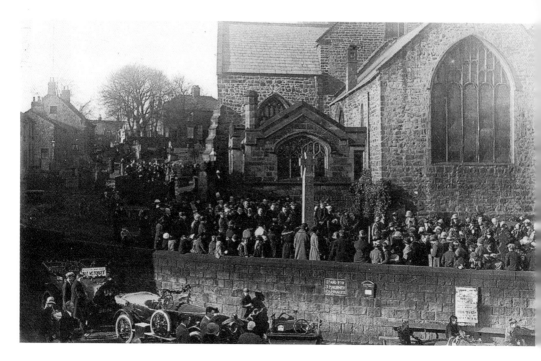

War Memorial Cross, 1923
The Remembrance Day service at the war memorial cross in the churchyard, from a postcard dated 1923. One of the cars parked at the front has a sign reading 'lest we forget'. In 1966, the cross was moved to the memorial gardens, created in the mid-1950s in Bondgate on the site of Grove House, later the British Restaurant.

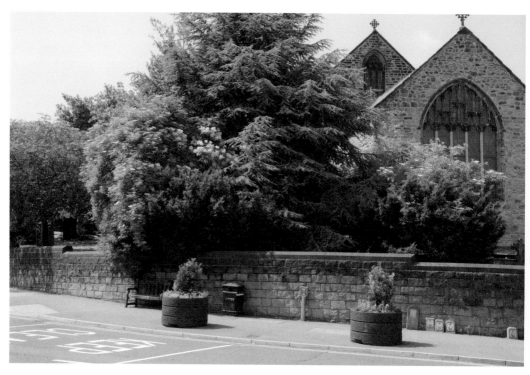

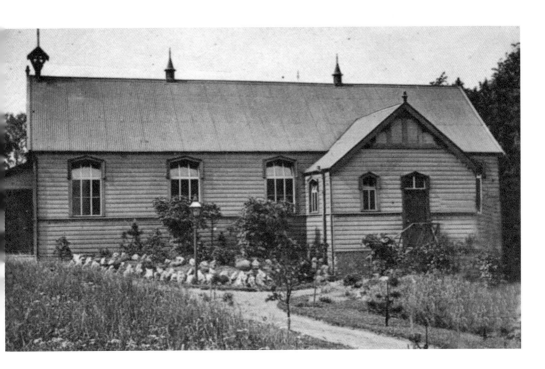

St Peter's Church

St Peter's mission church stood on Pool Road. It was built at a cost of just under £700 in 1902, made primarily of wood with a corrugated iron roof, which was painted red. The church closed in 1942, and was briefly used by another church from Bradford before demolition to make way for housing. There is a plaque in the parish church commemorating the life of Tom Smith, the preacher at the church.

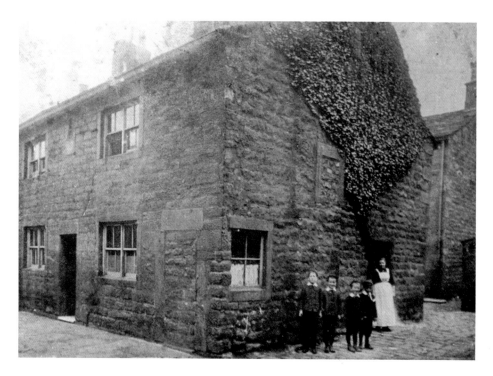

Number 13 Sugar Street, c. 1902

This photograph is said to have been taken around 1902 by William Brockbank of No. 7 Sugar Street. Emma, wife of coal merchant John Parnaby, stands by the side door; the boys are most probably her family. Sugar Street was the short, narrow street between Bondgate and Nelson Street, now part of Crossgate, renamed when the road past the bus station was built in the late 1930s. The cottage was later a pottery, then a restaurant, and it is now a prizewinning 'Real Ale' pub.

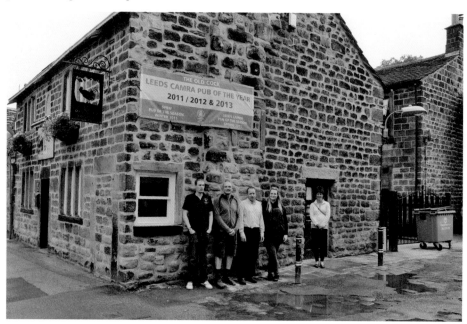

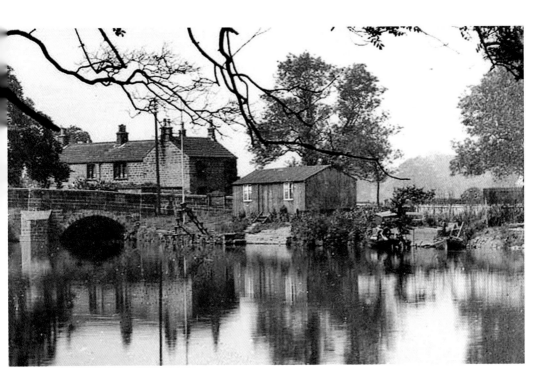

Otley Bridge, *c.* 1911

The north side of the bridge around 1911, with the swimming hut and diving board. The swimming club was formed around 1900; its first president was Mr J. Wallace, who was a police chief constable in Scotland before moving to Otley. On the other side of the road are the houses that were demolished in the 1960s because they were prone to flooding.

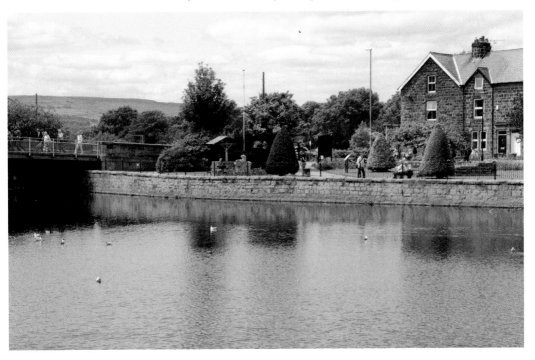

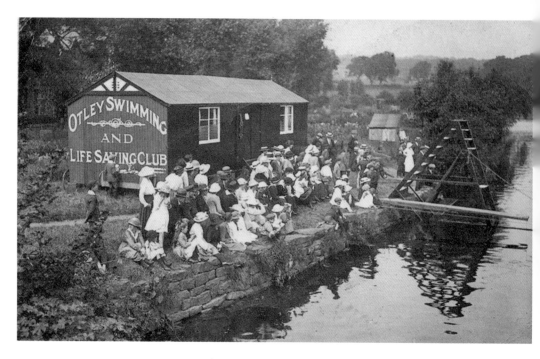

Otley Swimming and Life Saving Club, *c.* 1911
A crowd watching the swimmers at Otley Swimming and Life Saving Club. The club was at first restricted to males, and by 1904 there were 200 members; a quarter of them had been taught to swim at the club. The first mixed swimming took place in 1906, with three young ladies from Bradford causing a sensation by racing with the men.

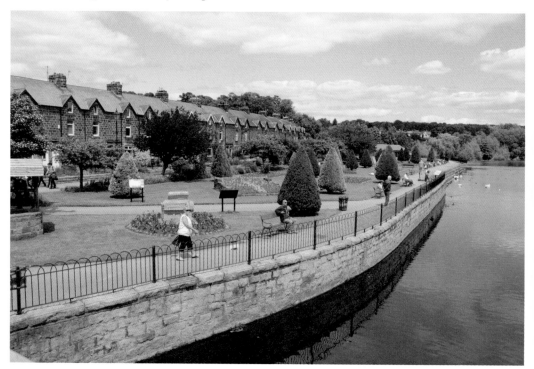

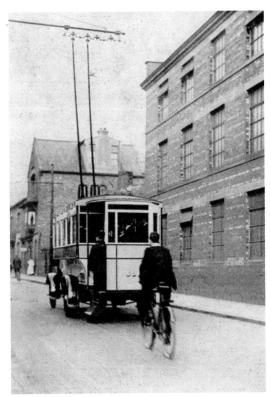

Westgate, _c._ 1915
A trolleybus making its way along
Westgate, towards the town centre; it
looks quite new, so the year is around
1915 which was when the service started.
The large building on the right is part
of the Atlas works of Payne's printing
machine manufacturers.

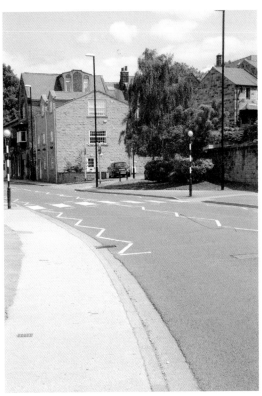

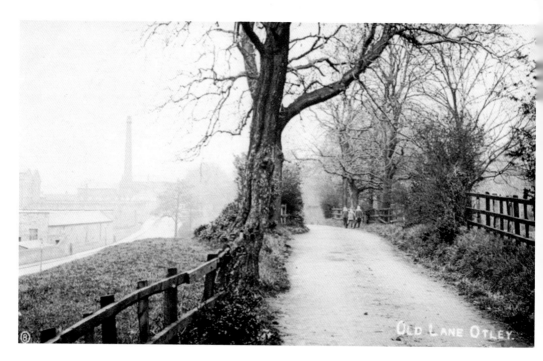

Old Lane

Old Lane in 1906 is West Busk Lane, in a postcard published by 'Robinson, The Library, Otley'. This is the east end of the lane, with Otley Mills in the background. The road on the left is the once very busy road to Ilkley, now part of the bypass, which you can just see on the left in the new photograph, and Old Lane is just a footpath.

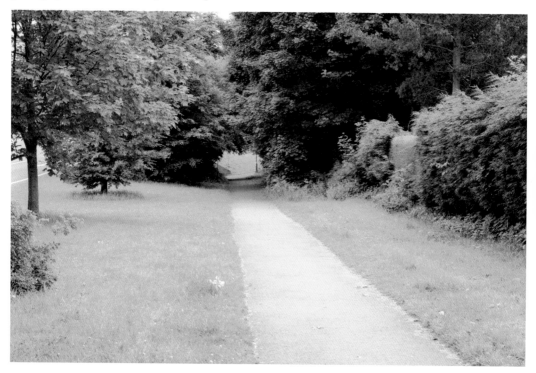

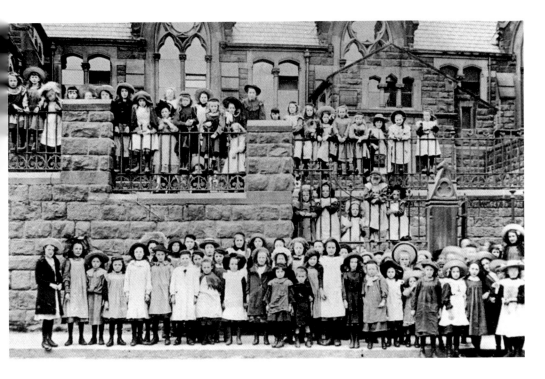

Westgate Council School, Ilkley Road

The girls from Westgate Council School on Ilkley Road pose wearing their bonnets and smocks. This was the original Duncan's Mill School of 1871 for the girls who worked part-time in the worsted spinning mill. The Otley Schools Board took over in 1885, and the school was extended in 1907 with buildings on Scarborough Road. It is still used today.

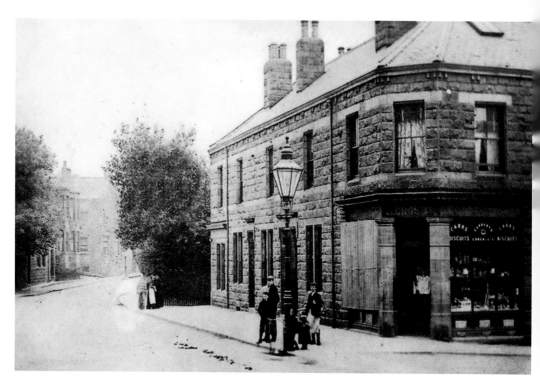

Westgate, Junction with Guycroft, 1909
Looking west in the distance, you can see Union Street on the left. It was later demolished to build sheltered housing. Miss S. Crosby's shop was a confectioner's, draper's and dressmaker's; its last use before conversion into a house in 2012 was as a working goldsmith's.

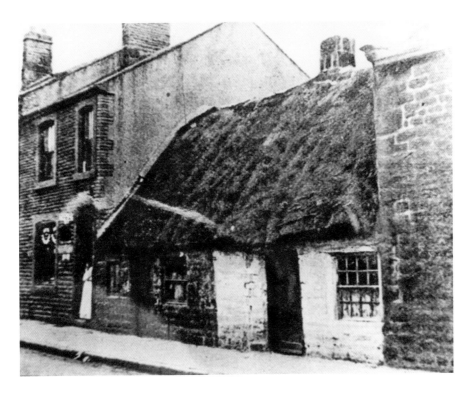

Number 18a Walkergate

The site of the last thatched cottages in Otley at No. 18a Walkergate. This street was named after the place where the fullers or walkers plied their craft of fulling cloth – that is, walking or treading it. On the right is a large stone building, which is probably the last vestige of the tannery, the entrance of which was in Crow Lane. The nearby car park was made possible by the demolition of houses known as Paradise Square, but its earlier name was Tanners Fold.

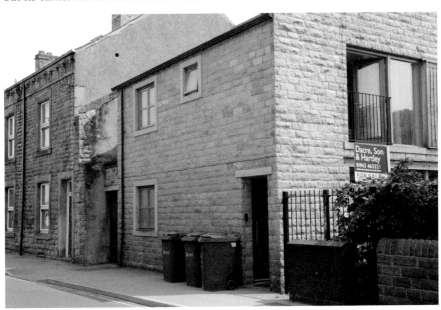

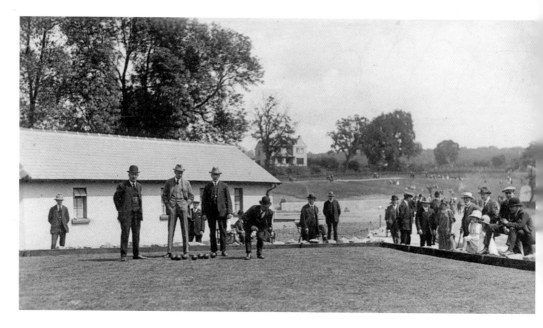

The Bowling Green in Wharfemeadows Park, *c.* 1925
The park was laid out in 1924 by the Otley Urban District Council, the largest part of the land being given by Major Fawkes of Farnley Hall. At this time, charges for the use of the green were 2*d* each per hour.

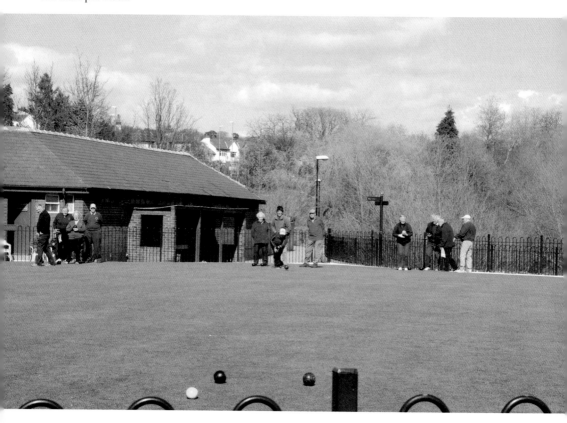

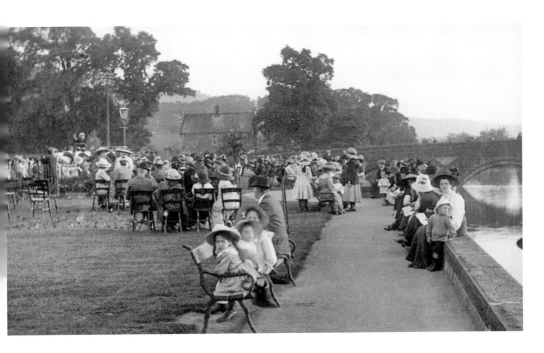

Manor Parade Gardens or 'Titty Bottle Park'

A postcard view of a concert in Manor Parade Gardens, known locally as 'Titty Bottle Park', published by Henry Mounsey around 1914. The council acquired this land from Mrs Constable of the Manor House in 1909. Before Wharfemeadows Park opened, this was a popular meeting place for mothers and babies with their prams, hence the name.

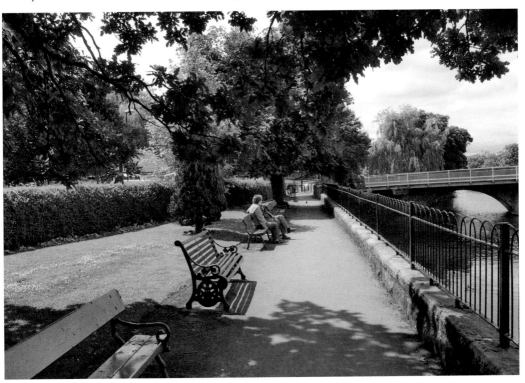

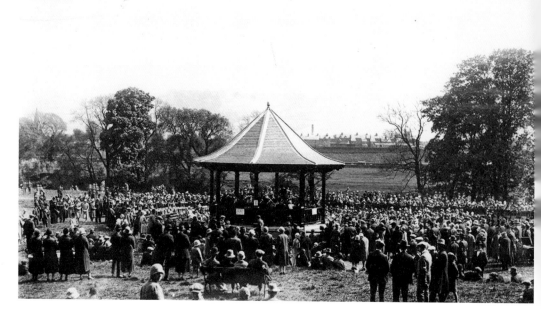

Bandstand, 1930s

Here, a view from the 1930s shows a band playing in the bandstand, surrounded by crowds. To quote the 1926 *Guide to Otley* describing the scene at Wharfemeadows: 'A feature of the park is music, good bands being engaged for each Sunday and occasional weekdays during the summer. The new bandstand is in a sheltered and pretty corner of the park, and among the recent engagements have been bands of note, such as St Hilda Colliery, Irwell Springs and Black Dyke Mills.' The bandstand was demolished in 1962.

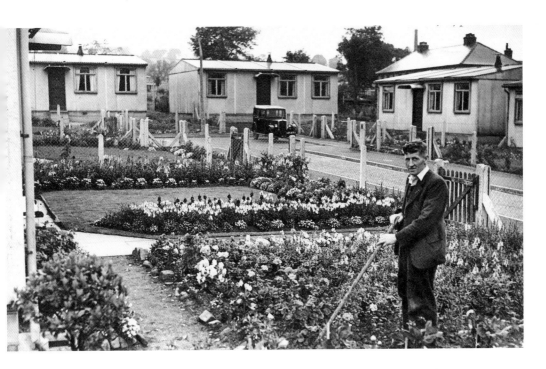

Weston Drive, 1953

This photograph, taken in 1953, shows Mr J. Wood tending his garden, which had won the Otley Council Coronation Garden Competition. The houses, known as prefabs, were first delivered to the site off Weston Lane in November 1947, where the sections were assembled on concrete bases and connected to the main services. The houses came complete with a bath, a sink, fitted cupboards and a refrigerator, and were let to local families by the council. They were very popular, but were eventually demolished in the early 1970s. This area became sheltered housing called Bennett Court.

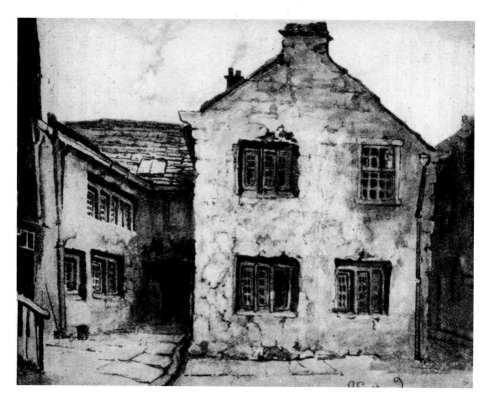

The Black Bull

The Black Bull, seen from the rear on Newmarket, is believed to be the oldest building in Otley and has been much altered over the years. It is thought to date from the sixteenth century. You can still see traces of the old mullioned windows inside the rear entrance. The old water pump in the yard was famous for the quality of the water and the fact that it never ran dry.

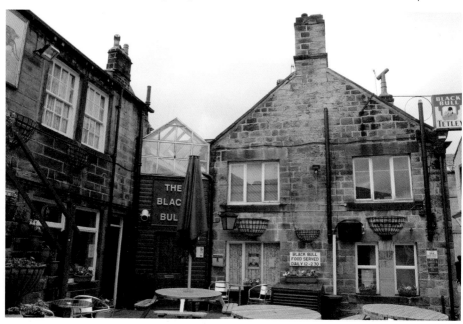